D0862688

FACES ON PLACES

DISCARDED

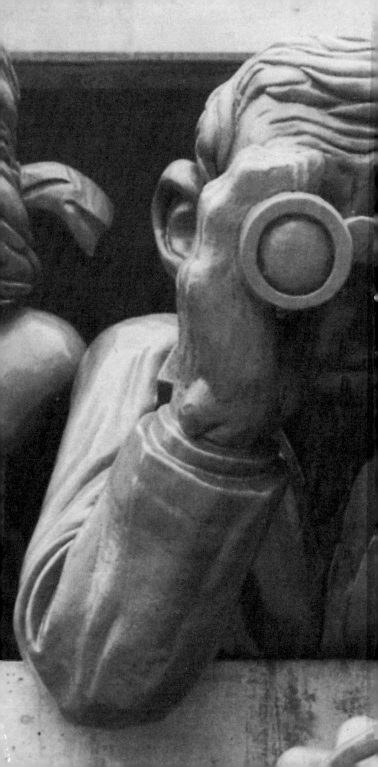

FACES ON PLACES

A GROTESQUE TOUR OF TORONTO

TERRY MURRAY

Forewords by CHRISTOPHER HUME
and JOE CHIFFRILLER

ANANSI

Public Library
Incorporated 1862
Barrie, Ontario

Copyright © 2006 Terry Murray

All rights reserved. No part of this publication may be reproduced
or transmitted in any form or by any means, electronic
or mechanical, including photocopying, recording, or any
information storage and retrieval system, without permission
in writing from the publisher.

Published in 2006 by
House of Anansi Press Inc.
110 Spadina Avenue, Suite 801
Toronto, ON, M5V 2K4
Tel. 416-363-4343
Fax 416-363-1017
www.anansi.ca

Distributed in Canada by
HarperCollins Canada Ltd.
1995 Markham Road
Scarborough, ON, M1B 5M8
Toll free tel. 1-800-387-0117

Pages 209–210 constitute a continuation of this copyright page.

10 09 08 07 06 1 2 3 4 5

LIBRARY AND ARCHIVES CANADA CATALOGUING IN PUBLICATION DATA

Murray, Terry, 1954–
Faces on places : a grotesque tour of Toronto / Terry Murray.

Includes bibliographical references and index.
ISBN 0-88784-741-2

1. Stone carving — Ontario — Toronto.
2. Decoration and ornament — Ontario — Toronto. I. Title.

NA3513.T6M87 2006 729'.5 c2005-907429-9

Cover and text design: Ingrid Paulson
Front-cover photograph: Queen's Park
Pages ii–iii photograph: Rogers Centre
Pages vi–vii photograph: U of T Admissions Office
Page 181 photograph: Lillian H. Smith Library

Canada Council Conseil des Arts
for the Arts du Canada

ONTARIO ARTS COUNCIL
CONSEIL DES ARTS DE L'ONTARIO

*We acknowledge for their financial support of our publishing program
the Canada Council for the Arts, the Ontario Arts Council,
and the Government of Canada through the Book Publishing
Industry Development Program (BPIDP).*

Printed and bound in Canada

To Kathy Margittai,
who helped me find
what I thought I had lost

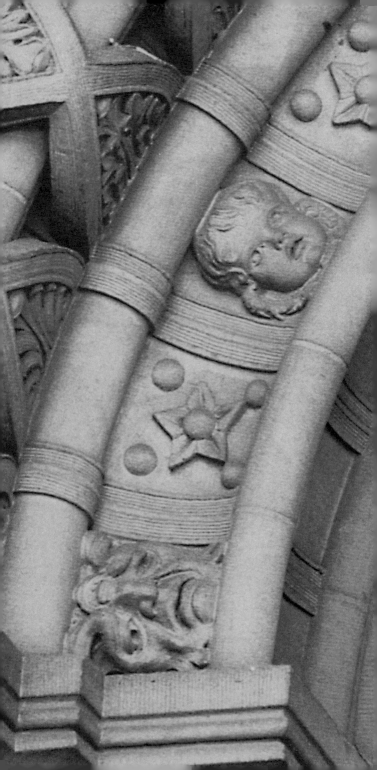

CONTENTS

FOREWORD *by Christopher Hume*

TORONTO IS A CITY of secrets. It reveals itself slowly, bit by bit, detail by detail. This is as true of the physical landscape — with all its hidden ravines — as it is of our cultural topography.

Toronto's architecture is no different. Just ask Terry Murray, whose book, *Faces on Places*, will come as a revelation to even the most diehard city explorer. Who knew Toronto possessed such a rich heritage of carved stone buildings? Who knew the city and its buildings were so alive with dragons, griffins, and grotesques, let alone cherubim, seraphim, and plain ordinary angels?

It is true that many if not most of us have wandered past the old Postal Delivery Building at the foot of Bay Street and admired Charles Dolphin's eccentric — and wonderfully politically incorrect — depictions of communications through the ages. Now that those scenes have been incorporated into the otherwise unremarkable Air Canada Centre, they have a larger audience than they ever did before.

And certainly, many Torontonians are familiar with the carvings that enliven the façades of Old

City Hall, E. J. Lennox's masterpiece and a monument of High Victorian optimism.

Murray documents these buildings but goes well beyond them and delves into a number of lesser-known examples of the stone carver's art: the old Hospital for Sick Children (now the Canadian Blood Services Building) on College Street, the marvellous 1920s apartment complexes around Avenue Road and St. Clair Avenue, and those heroic high-relief portraits of Canadian heroes at the University of Toronto.

The subtext of *Faces on Places* is our continuing struggle to create a distinctly Canadian mythology, to develop a language, architectural and aesthetic, that enables us to tell our own stories. Of course, we have not always been successful. In her discussion of architect and fierce cultural nationalist John Lyle, Murray makes it clear that his efforts, as picturesque as they may be, have been largely forgotten. Despite the affection we feel for Lyle's Runnymede Library in Toronto's West End — it was even featured by Canada Post on a stamp — it stands as a one-of-a-kind landmark, a singular attempt to establish a recognizably Canadian iconography.

But all is not lost; the past remains alive in our city, though we have done enormous damage, especially since the 1960s and '70s. But as Murray also makes clear, the tradition of decorated buildings is alive, if not always well. She pays deserved homage to the Lillian H. Smith Library, that delightful downtown branch designed by unsung architect Phillip Carter in the 1990s during the darkest days

of the recession that brought most development to a halt. That Carter managed to hang on to his griffins in such hard times is a minor miracle, entirely worthy of celebration.

Murray also singles out Michael Snow's whimsical "gargoyles" at the Rogers Centre, formerly SkyDome. One of Canada's leading artists, Snow showed a different side of his character in this two-part work, *The Audience*, namely his playful sense of humour, not something normally associated with contemporary art.

Then she writes about a piece Snow is preparing for the Pantages Hotel and Spa on Victoria Street. Comprising a series of seven plasma screens that will be installed in blind windows on the front façade, the *Windows Suite* will bring the notion of architectural embellishment fully into the twenty-first century. Not that video art could ever replace carved stone, but, as Murray points out, it represents an effort to satisfy the age-old human desire for narrative.

The modernists insisted that architecture was simply a matter of form and function. How wrong they were! To read Murray's welcome volume is to be reminded that the buildings we love are those that speak to us. The stone in which they are writ may be worn down by wind, snow, and rain, but the tales they tell never lose their appeal.

C.H.
Toronto

FOREWORD *by Joe Chiffriller*

JUMP IN ANYWHERE within these pages and you will come to suspect that Terry Murray was herself a stone carver in a former life. With a passionate interest in Toronto masters who have come before her, she has unearthed old documents and then fearlessly scaled the rooftops to inspect and record their work. Now she has climbed back down and caught her breath. The result is a completely modern look at stone carving.

In addition to bringing the subject down to earth, Terry also includes a bit of mystery and colourful historical background, as well as tales of the backbiting politics, time constraints, and money concerns that went into the creation of these carved faces. Unlike the authors of most books on the subject, Terry does not speak in historical riddles or attempt to preserve the subject — cue the dramatic choral music — as A Work for the Ages. This is a lively story expertly told and, as such, *Faces on Places* may just become a stone carving classic.

For me, the real importance of this book lies in how it reveals the strength of the human spirit

originally captured in these faces. My own experience as a stone carver makes me an enthusiastic fan of both the form and method of their creation. If you had spent time in the early 1980s working on carvings at the Cathedral of St. John the Divine in New York, you too would quickly have learned that the trade was on an equal footing with that of masons, bricklayers, and others who laboured under orders: get it done. Get it done now.

'Twas ever thus. In ancient Greece, even a temple to a favourite god had to be completed on time, and under budget. In Rome, sculptors were often praised for their thoughtful lyricism, while architectural stone carvers were most likely threatened with banishment for taking too long. (Also read the writings of St. Bernard as he demanded to know the purpose of all that extra "decoration" from *his* crew. In a twelfth-century diatribe, he finally posed the eternal question of bean counters everywhere when he asked, "…and what is it costing me?")

Today, the stone carver's art is still created with a stealthy eye, hurried, raw, and often virtually two-dimensional. But it also continues to reveal something about the human psyche that few classical sculptors would dare to capture in stone. Such raw expression reached its height in the Dark Ages, when stone carvers were let loose on cathedral towers to take on monsters, gargoyles, chimeras, and dragons. Then, having gotten terror and damnation down pat, they fearlessly bit the hand that fed them, through grotesque representations

of the church administration. In some ways, it is a wonder the trade survived. But survive it did, and today it is the most primitive aspects of stone carving that continue to fascinate in the postmodern world when we all supposedly should know better.

Through the centuries, commercial stone carving reflected the tastes of the day. From the classical symbolism of the Renaissance to the gentler era of nymphs and goddesses during the Romantic period, stone carving hit new heights in the nineteenth century with the return of the primitive face and the flying buttress. It seemed everyone went grotesque-crazy during the Neo-Gothic period, an era that was an allergic reaction to the Industrial Revolution and the world spinning mechanically out of control.

Around the same time, the stone industry — forever the free thinkers of the construction trade — made history when a group of disgruntled Australian stone masons and carvers stopped work on April 21, 1856. They marched straight from Melbourne University to Parliament House to demand an eight-hour work day. Today, historians point to the protest as the work action Down Under that inspired the celebration of Labour Day around the world.

Eventually, a large number of stone workers migrated with their families to North America, where the best of them excelled in the culture of time-is-money. Carefully watched as they chipped away, New World carvers continued to create works of art worth preserving. Luckily, they can still be

seen today in the churches and civic architecture of Chicago, New York, and Toronto, and in the photographs within this book.

From an insider's viewpoint, these works in stone symbolize the best characteristics of the trade itself, capable of inspiring future generations in ways of courage, laughter, craftsmanship, and a sense of wonder. Today, when we least expect it, architectural stone carvings jump out at us with eternal truths of beauty, courage, and good battling evil. But real estate and economic interests continue to force a showdown between modern aesthetics and what we want to preserve, especially when it comes to those historic faces that for a century or more have benignly watched over us all. Now, face to face, it may be our turn to watch over them.

J.C.
New York

INTRODUCTION

ORONTO, A CITY OF GLASS, steel, and stone, is not considered to be the architectural mecca of North America. Yet, it has some architectural features that are unjustly taken for granted, if noticed at all, by residents and tourists alike: the gargoyles, grotesques, and other creatures that populate the towers, reliefs, and friezes on the city's buildings. Once in the habit of looking up, sometimes only a few storeys, you will see extraordinary stone faces all over the city — even on buildings you have passed every day for years.

That is what happened to me. I have spent the last ten years scouring the city for these "faces on places." I have photographed the stone denizens of more than sixty Toronto buildings, and brought a reporter's research skills to bear — interviewing architects, stone carvers, and building occupants, scouring archives of the original architectural plans, leavening the mix with a dash of speculation — in order to reveal who or what these creatures are and why they are there.

I remember the precise date I started looking.

Perhaps what is more remarkable is the notable occasion when I did not become taken with them. That was on a June day in 1986, while I was in Paris on a business trip and found myself outside Notre Dame Cathedral. It was my first trip out of North America, the holiday portion of which I had spent mostly in and around London, where I had crammed my days with sightseeing. So I deliberately planned a more low-key approach to Paris, where I had one free day before the start of an international AIDS conference I had been sent to cover by *The Medical Post*.

After visiting the Louvre, I made a pilgrimage to Shakespeare and Company, the English bookstore on the Left Bank. I carefully mapped my route there from the Louvre, not noticing until I was upon it that the path took me past Notre Dame. Having taken in virtually every ecclesiastical building I encountered in England — and being impressed but overwhelmed — I thought of the tourist's ABC, "another bloody cathedral." So I walked past possibly the most famous cathedral in the world — and a veritable shrine for the true gargoyle aficionado — and carried on to the bookstore.

No, the true date of my architectural awakening was June 13, 1993. I was flying back to Toronto from another medical conference, and changed planes in Chicago, where I bought the Sunday *Tribune* during the layover. The cover of the magazine section featured a montage of architectural detail with the title "Treasure Hunt: Long-lost Architectural Gems in Chicago's Neighbourhoods."

Inside, the generously illustrated article began, "We grew up in a city full of little treasures, and we knew it." It went on to describe the ten-year Chicago Historic Resource Survey that showed "there's more architectural and historical gold in Chicago neighbourhoods than anyone thought."

Toronto, on the other hand, is not especially noted for its architecture, and Torontonians have a long and shameful history of demolishing some of their best buildings. So I took the *Tribune* article as a challenge, and when I got home, grabbed my camera and set out in search of Toronto's architectural ornament.

My initial fascination was with gargoyles. (Strictly speaking, they are the creatures that contain a spout and protrude from buildings to carry water away.) My interest soon broadened to include most architectural sculpture, and I began seriously to hunt and record Toronto's architectural gems. This extended to obtaining special access to balconies, roofs, and scaffolding to shoot the faces that are barely visible from the street.

As my collection of photographs grew, so did my curiosity about who or what these details represented. Books about Toronto architecture led me to architectural journals, which led me to more buildings, which in turn led to more books and more journals — and to architects, historians, restoration experts, and building occupants.

When I realized that my photo albums, bits of paper, notebooks, and photocopied articles were the makings of a book, I wrestled with what to call

it. Not all of the stone creatures were gargoyles — not strictly speaking, anyway, but practically no one speaks strictly about these things anymore. Still, I felt uncomfortable using the term "gargoyle" to refer to all human and animal forms of architectural ornament. "Faces on places" seemed the best way to describe this collection. I wish I had coined the phrase, but it is what Suzanne Haldane called her 1980 children's book about stone creatures in the United States, *Faces on Places: About Gargoyles and Other Stone Creatures.*

The subtitle, "a *grotesque* tour of Toronto," is a pun on the word for another kind of architectural face — that of the purposely ugly, deformed stone creatures that are generally intended as unflattering caricatures.

Many of the buildings here — like the iconic Gooderham "Flatiron" Building and the former Bank of British North America — are notable for other architectural and historical reasons. But I am always startled when guide books, tour guides, and historical plaques ignore even prominent stone faces. This oversight continues despite the fact that Toronto is in the early stages of a renaissance in architectural sculpture. Nearly 150 remarkable buildings were demolished or compromised in the 1970s, 1980s, and even 1990s. After Kerr Hall at what is now Ryerson University was built in the 1960s, virtually no architectural sculpture was included in any new buildings until the late 1990s. Kerr Hall included controversial sculptures by Elizabeth Wyn Wood, Jacobine Jones,

Dora de Pédery-Hunt, and Thomas Bowie, some of the leading Canadian sculptors of the day. Then, in 1995, came the opening of the Lillian H. Smith branch of the Toronto Public Library, with two large griffins flanking its entrance and marking a return to architectural ornament. The most recent example is the addition — reinstatement, actually — of four gargoyles to the tower of Old City Hall in 2003.

This book is a catalogue of Toronto gargoyles and other humanoid architectural ornament — from the "usual suspects," such as the legendary grotesques on Old City Hall, to neglected and unnoticed faces like those on the former head-quarters of Confederation Life. *Faces on Places* also tells the stories behind those carvings — who they are and what they represent. Some of this is new information based on identifications I made myself. In other cases, a little digging has corrected decades-old mistaken impressions. For the rest, descriptions have been brought into the light from the recesses of libraries and archives.

At the same time, this is an idiosyncratic collection. I meant to limit the faces here to human and human-like figures, but some important animals begged to be included.

The University of Toronto downtown campus is home to enough faces to fill their own book, so its buildings are not represented here — with four exceptions. Three have not always been part of U of T, and the fourth contains figures I think of as my own personal find.

The book is organized thematically, according to the nature of the sculptures (true gargoyles, portraits, mythological characters, symbols, and so on), but it also contains an index of building addresses and maps for walking tours. That way, you can see the faces in person if the gargoyle-hunting bug gets to you too — which I suspect it will. After more than a decade of hunting, I still look up wherever I go, and I bet that when you see what is here, you will too.

FACES ON PLACES

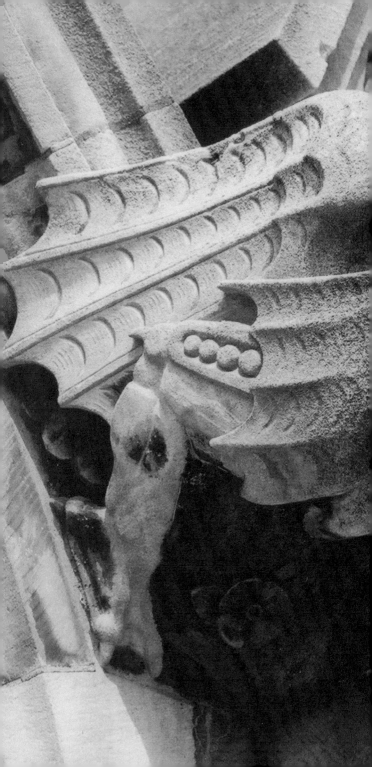

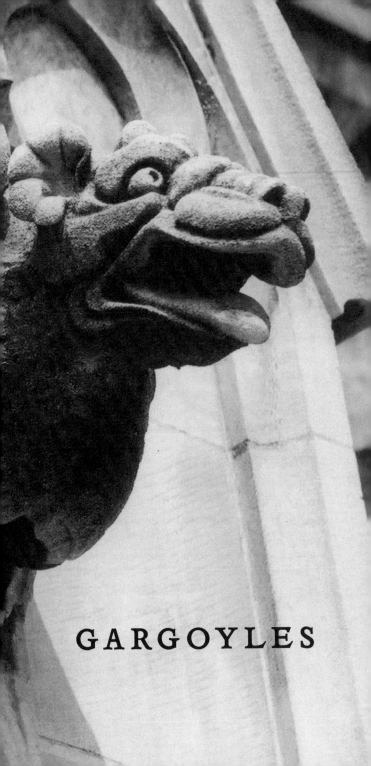

GARGOYLES

THEORIES ABOUND as to why Western architecture has been ornamented with figures — whether they be gods or mortals, celestial beings or rude humans, the Devil himself or souls trapped in stone on their way to hell, recognizable animals or bizarre hybrids. One school of thought is that traditionally they were used by the Church to instruct the illiterate masses or terrify them into compliance with the Ten Commandments. Another suggests that the figures were believed to keep away evil spirits and protect a building's occupants.

In some cases, carvings were functional. In fact, the late British architect and mechanical engineer J. E. Gordon claimed that they actually kept the walls upright. In his 1978 book *Structures: Or, Why Things Don't Fall Down*, he explained that "in a building with any pretension to sophistication, there is most likely to be at least one oblique force arising from the sideways thrust of the roof members, from archways or vaultings or from various other forms of construction."

That oblique force then displaces the "thrust line"—which should run neatly down the middle of the wall and keep it vertical—into a potentially destabilizing, curved path. The logic is counterintuitive, but adding weight to the top restores a wall's stability by bringing "an erring thrust line back, more or less, to where it ought to be," Professor Gordon explained.

"If it is that sort of building and you can afford it, a line of statues will always help. This is the structural justification for the pinnacles and statuary on Gothic churches and cathedrals."

There is another, more immediately apparent function of some sculpture on buildings: the drainage provided by gargoyles that stretch out from buildings and overhang streets and squares. Strictly speaking, a gargoyle is stone-covered plumbing with a face—a fantastic open-mouthed creature that carries water away from buildings, protecting the building's walls and foundations from erosion.

A colourful description of gargoyles and their function appeared in the *Toronto Daily Star* in 1932, in the midst of the controversy over the fate of the creatures on Old City Hall (which is discussed below). A cartoon shows a "Professor Chickwick" standing before a blackboard on which he has drawn a perching gargoyle emitting a torrent of rainwater.

The professor explained, "If you walked along the streets, say during the reign of Queen Elizabeth [I], you would notice the gargoyles pointing from

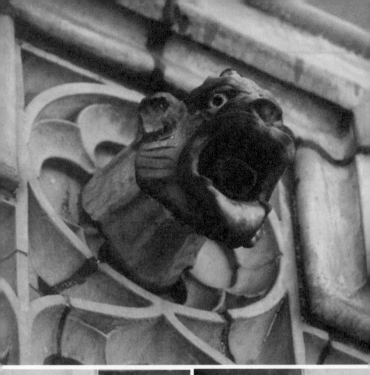

the roofs all around you. They were as common as
the signs which hung over every door. If it were a
rainy day you had a very unpleasant walk, for the
signs swung and rattled, flinging the drops around,
while the water poured from the gargoyles in a
hundred different streams upon your head.

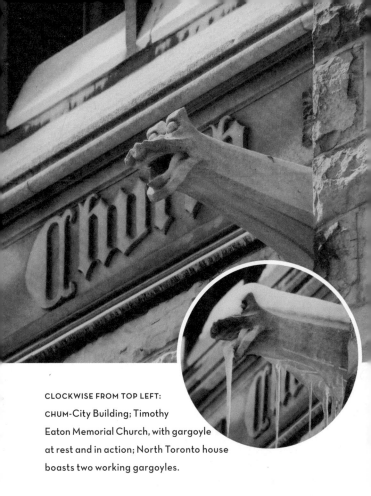

CLOCKWISE FROM TOP LEFT:
CHUM-City Building; Timothy
Eaton Memorial Church, with gargoyle
at rest and in action; North Toronto house
boasts two working gargoyles.

"Numbering shops and houses of course did away with the swinging signs. Drain pipes caused the gargoyles to disappear."

But gargoyles did not completely disappear. Three striking sets of examples in Toronto can be found on the CHUM-City Building, a residence in North Toronto, and Timothy Eaton Memorial Church.

It is difficult to photograph gargoyles in action. They are generally found near the tops of buildings,

meaning that the photographer has to shoot upward, risking getting his or her equipment soaked — or, at a minimum, getting raindrops on the lens, possibly distorting or obscuring the picture.

A safer and dryer alternative is to shoot *evidence* of the gargoyle's work. Melting snow pours through a gargoyle just as rain does, and if the cycle of thawing and freezing is just right, the freeze will turn the dripping snowmelt into an icicle. (This is a favour nature provides the photographer only; as will be explained shortly, freeze-thaw cycles are the enemies of stone.)

TOP: Canon Theatre

BOTTOM: Jarvis Street Baptist Church

Other stone creatures look like gargoyles but do not have pipes or conduits through their mouths. Instead, they have channels in their backs to conduct water over their heads and away from the buildings.

There are still other creatures that look like gargoyles but have no visible means of drainage. These too can be called "gargoyles," according to Walter Arnold, an American stone carver whose gargoyles appear on Washington National Cathedral in the U.S. capital and Tribune Tower in Chicago.

"There is the technical, pure usage and the accepted everyday use," he said in an interview. "Purists are very rare. In the pure sense, even an unornamented scupper which extends out of the wall is a gargoyle, and any carved creature which is not a drain spout is a grotesque.

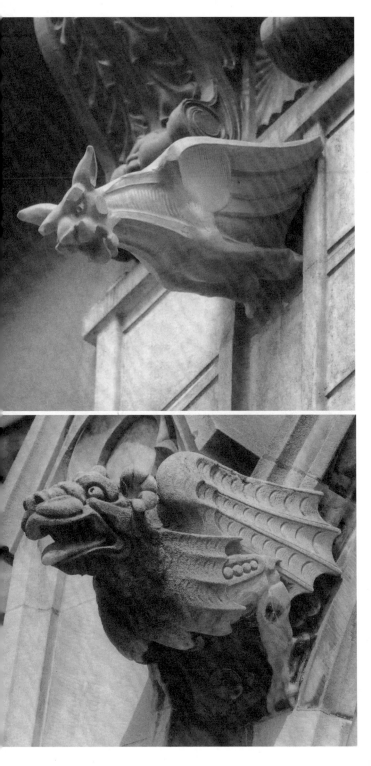

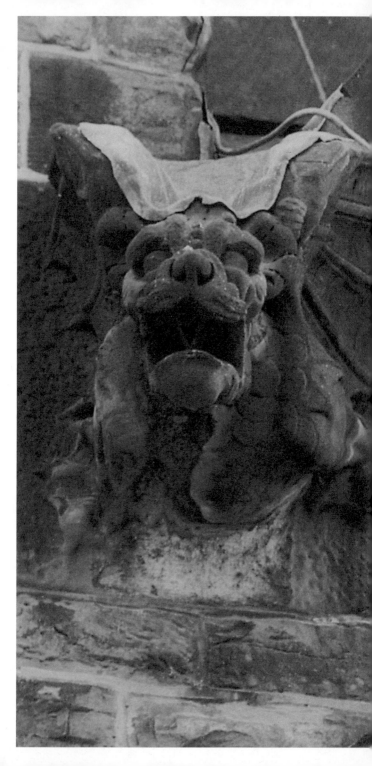

"However, language changes with common usage, so I feel it is acceptable to use the term 'gargoyle' in the generic sense."

But just why there are gargoyles on these largely early-twentieth-century buildings is not clear. Most church histories focus on the congregation; when they deal with architecture at all, it is usually to do with the interior.

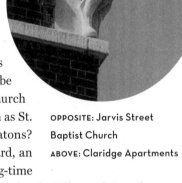

But how can four gargoyle-like figures flanking the main doors of Jarvis Street Baptist Church be ignored? And the church that used to be known as St. Timothy and All Eatons? The late R. H. Hubbard, an art historian and long-time chief curator at the National Gallery of Canada, described it as "somewhat more interesting outside than in."

OPPOSITE: Jarvis Street Baptist Church

ABOVE: Claridge Apartments

The gargoyles on the North Toronto house can be explained, at least in part, by the fact that the builder and first resident was a stone merchant.

Although there is no explanation given for the inclusion of the "generic" spoutless gargoyles on the four corners of Old City Hall, their history is well documented. They are Toronto's newest, placed on the tower in 2003.

In fact, they were *re*placed. A dozen gargoyles sprang from the building when it opened in 1899 as Toronto's third city hall — from the corners of the clock tower, as well as lower down on the building, from the centre part of the north façade and from the turrets flanking both side entrances.

The clock-tower gargoyles weighed an estimated 900 kilograms each, and cantilevered out about three metres from the 103.6-metre tower. But by 1921, the gargoyles' unique posture (projecting horizontally instead of bending closer to the building) and the erosive forces of high winds and freeze-thaw cycles started to take their toll.

On the afternoon of Tuesday, March 8, a gargoyle's jaw dropped — literally — from the northeast corner of the clock tower. It fell more than thirty metres, crashed through the Old City Hall roof and narrowly missed killing James Marshall, a draftsman in the works department drafting room.

"It was noticed lately that some of the New Brunswick sandstone of which these odd ornaments are made was crumbling," according to a front-page story in the *Toronto Daily Star* the next day, "but that part of one should loosen and fall through the roof was hardly anticipated."

The immediate reaction of city architect G. F. W. Price was to propose removing the gargoyles. Not surprisingly, E. J. Lennox, Old City Hall's architect, disagreed. "'There's no need of removing them,' declared Mr. Lennox to *The Star* to-day, and he spoke with quite evident feeling," said a story a few days later.

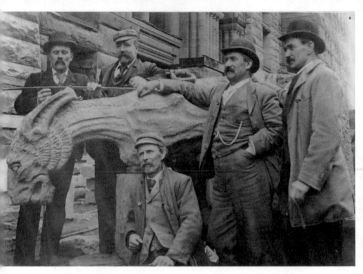

An Old City Hall gargoyle — but the record is not clear about whether this one was destined for the clock tower. The record is similarly unclear about whether master stonemason Arthur Tennison is on the left or seated in front of the gargoyle.

CREDIT: CITY OF TORONTO ARCHIVES, FONDS 1268, ITEM 214

"'No decent architect would do such a thing as to remove them all. It will spoil the general appearance of the city hall,'" he added, suggesting another piece of gargoyle might not fall for another hundred years.

However, a subsequent story said information had been leaked to the paper that two other jaws had fallen "some time ago." More fragments were to break away and eighteen years were to pass before anything definitive was done. It was not until 1939 that the gargoyles were finally removed.

The entire Old City Hall was threatened with demolition when the fourth and current city hall opened across the street in 1965 and planning began for the Eaton Centre. However, a group of

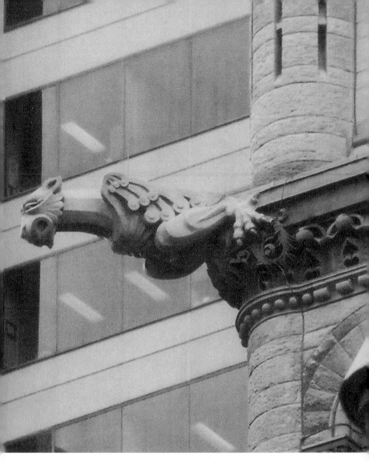

New gargoyles on Old City Hall

concerned citizens, known as the Friends of Old City Hall, convinced the city to preserve the earlier building. (It was declared a National Historical Site by the Historic Sites and Monuments Board of Canada in 1989.)

With that battle won, talk turned, by the early 1970s, to replacing the missing gargoyles. According to the glacial pace at which civic decisions are often made, it would be nearly twenty years before

that project began. In 1991, the Ventin Group, an architectural firm with a strong heritage bent, began a twelve-year, $35-million renovation of Old City Hall, culminating in the return of the gargoyles.

The Ventin architects were not actually able to resurrect the old gargoyles, which had been chipped off the tower. No fragments survived and there were no drawings or detailed photos of the originals.

"We've learned from other gargoyles on the building what their style would have been," said Peter Berton, the partner in charge of the renovation. "Our gargoyles follow the silhouette of the originals, but we didn't have intricate details, so we didn't make replicas.

"We like to work from the information we have. When you can replicate a detail, you should. When you can't replicate a detail, you should avoid conjecture."

(The *Star*'s 1921 front-page report of the first falling gargoyle was accompanied by a photo, already more than twenty years old, that was said to be one of the tower gargoyles before it was hoisted into place. The City of Toronto Archives now holds the photo, and its notes say the gargoyle was *not* from the tower.)

It is believed that the four original gargoyles were all different, but the new models are all identical. They have the look of stone but in fact are made of lightweight bronze. Their creation was a joint effort by the Ventin Group and the classically

trained stone carvers at Traditional Cut Stone Ltd. Joseph Por, the Ventin contract administrator, sent an archival picture of the tower with the gargoyles to the carvers, who produced a sketch of the new gargoyle.

"The sketch showed the gargoyle with a closed wing, instead of being open for flight as in the photo," Por said of the design the Ventin architects approved. "And on the tower, there are remnants of where the gargoyle claws were attached to the stone. They show that the (original) gargoyle had a narrower stance."

Each full-size, 136-kilogram gargoyle was then produced and erected through the additional work of MST Bronze Limited Art Foundry, Heather and Little Limited, and Clifford Masonry Limited, all of Toronto. The new gargoyles earned the Ventin Group an honourable mention in Toronto's 2005 Architecture and Urban Design Awards.

"These flamboyant Victorian Romanesque details, replacing originals that once adorned the clock tower of E. J. Lennox's Old City Hall, recall a time and architectural taste very different from our own," the jury said, "hence their value as reminders of the mental worlds through which Toronto has passed in its journey to the present, and as gracious enrichments of the historical layering the jury believes to be crucially important in urban life."

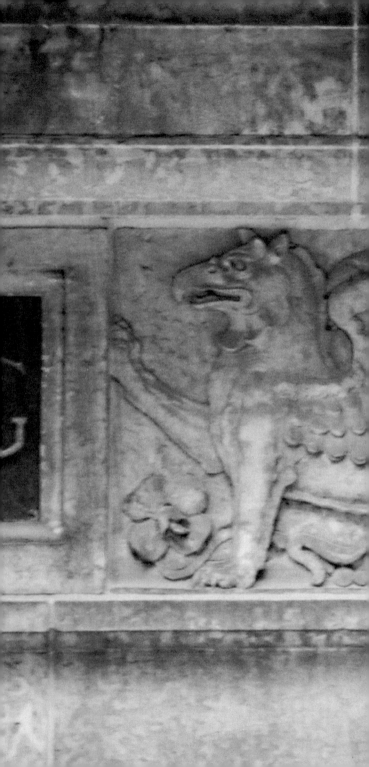

GRIFFINS,
AND OTHER
THINGS
WITH WINGS

GRIFFINS (SOMETIMES also spelled "griffons" or "gryphons"), which form another category of architectural sculpture, merit a separate discussion because, at first glance, Toronto seems to have an impressive assortment of these half-lion/half-eagle figures.

The griffin has a specific arrangement of lion and eagle parts. Its foreparts — the head, chest, and forelegs — are eagle, and hind parts — the rear, back legs, and tail — are lion. Its eagle head also has pointed, upright ears.

Combining the features of the king of beasts and the lord of the air, the creature is described as having mastery of the earth and sky, with the flight and penetrating vision of the eagle and the strength, courage, and majesty of the lion. However, some art historians have suggested that the dual nature of the griffin negates the strength of both animals, depriving it of the ability to either soar like the eagle or walk nobly like the lion.

In several traditions, griffins are described as guarding hidden treasures, and gold in particular.

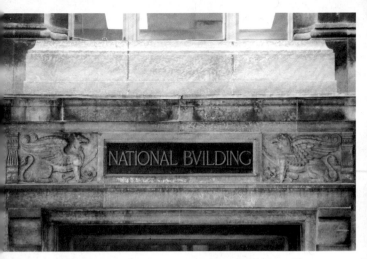

National Building griffins

So Bay Street should be the most likely place to find them. Four buildings on Canada's major money street, all within a block of Adelaide Street, have what appear to be griffins — the Northern Ontario Building, the National Building, Sterling Tower, and the Canada Permanent Trust Building. They were all built between 1925 and 1930, and the first three were the work of the same architectural firm, Chapman and Oxley. But closer inspection reveals that only one of the creatures is indisputably a griffin — the one on the National Building.

The figures on Sterling Tower and the Canada Permanent are just wingèd lions, with no parts at all of the eagle (which is actually the symbol of St. Mark the Evangelist, who is not known to have any responsibility for bankers, the domain of his colleague St. Matthew). The Northern Ontario Building actually has Egyptian-flavoured stylized felines that may be lions, but they have no apparent wings, feathers, or talons.

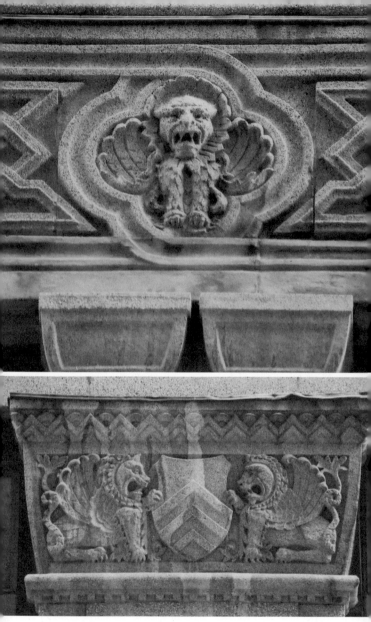

Sterling Tower wingèd lions

The Puma store on Yonge Street north of Eglinton Avenue is mostly noted for its patterned metalwork, but when its wingèd creatures are noticed, they too are generally referred to as griffins. But in contrast to the non-griffins of Bay Street, these are all bird, with no traces of lion.

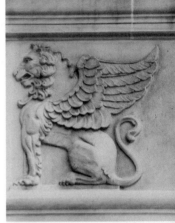

They most resemble the phoenix, the legendary bird that is said to have lived 500 years, burned itself on a pyre, and risen from the ashes to live again. Only missing are the flames that usually accompany representations of the phoenix — unless they were assumed, or the choice of bird was emblematic or a visual joke because the building was originally an office and showroom of the Consumers' Gas Company.

That the birds appear in stone at all is probably thanks to the clock, which is borne on the back of the same bird rendered in metal.

TOP: Canada Permanent Trust wingèd lion

ABOVE: Northern Ontario Building felines

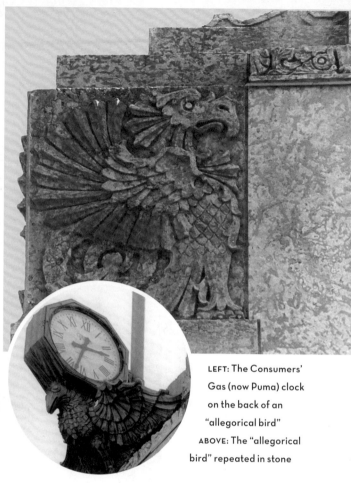

LEFT: The Consumers'
Gas (now Puma) clock
on the back of an
"allegorical bird"
ABOVE: The "allegorical
bird" repeated in stone

"A feature required on the building was a clock," according to a report in the building journal *Construction* in 1931. "As there was none in the immediate district it was felt that this would be a very useful as well as attractive item if it could be embodied in the design.

"In order that the clock might be visible north and south on Yonge Street it was necessary to extend it out from the face of the building."

Architect Charles Dolphin accomplished that by placing the clock on "an allegorical design of a bird," frozen as it was poised for flight to the east, thus allowing people on Yonge Street to see the time. The bird motif was repeated in stone at the corners of the building, atop fluted pilasters (squared and flattened pillars that protrude slightly from the building).

The Fairmont Royal York Hotel also sports creatures that somewhat resemble griffins but lack any leonine features. They may well be eagles, but they are quite hard to see unless you have an aerie-like vantage point. They are also a bit sparse.

The Royal York was built as a Canadian Pacific Railway hotel and was the seventh large hotel designed by the Montreal architectural firm of Ross & Macdonald. When it was officially opened in 1929, "for the most part, contemporary writers considered the Royal York Hotel's exterior an unqualified success," said David Rose.

But "most of the hotel's exterior ornament was under-scaled and was either lost against the vast wall surfaces or was too high up for its intricacies to be appreciated," Rose said in his study of the firm's hotel architecture.

The architects also incorporated a member of a different class of the mythological animal kingdom, posting a Pegasus in each of the four corners of the roof. The wingèd horse was the bearer of thunder and lightning to Zeus, the chief god of Greek mythology.

Dragons, reptilian mythological beasts that are similar to griffins, also appear on Toronto buildings.

Dragons are large, fire-breathing, wingèd reptiles with crested heads, enormous claws, and barbed tails. In Western tradition they are malevolent monsters, as in Christian symbolism, where they are associated with evil and more specifically the Devil. In some Eastern traditions they are wise and benevolent — perhaps not unlike a certain dragon immortalized in song, who frolicked in the autumn

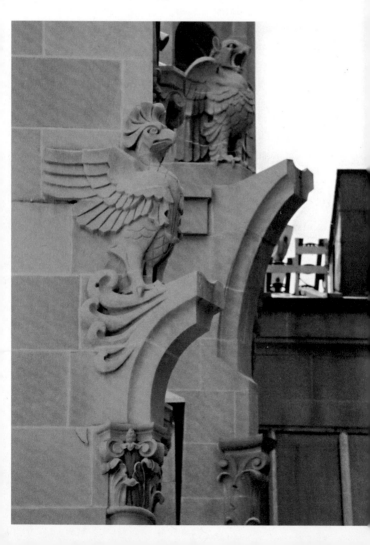

OPPOSITE: Royal York Hotel's eagles. ABOVE: Royal York Pegasus

mist and played with strings and sealing wax with a little boy named Jackie Paper.

The latter kind of dragon, appropriately, appears on an office supply and stationery store in midtown — although the building was originally

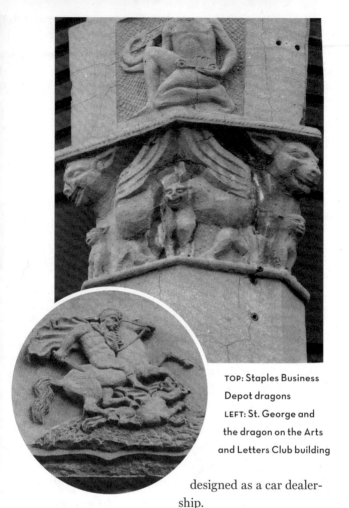

TOP: Staples Business
Depot dragons
LEFT: St. George and
the dragon on the Arts
and Letters Club building

designed as a car dealer-
ship.

The more ferocious example of
dragonhood is captured in stone, just as he is being
slain by St. George, on the Arts and Letters Club
building. The relationship between St. George (and
the dragon) to the club is indirect. The building was
completed in 1891 as St. George's Hall, the home of
the benevolent St. George's Society of Toronto, which
aided British immigrants. (That connection stems

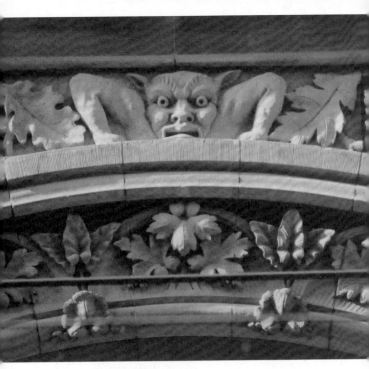

Confederation Life dragon

from St. George's position as the national saint of England. Legend has it that he slew a dragon to save a princess who was being offered as a sacrifice to the beast.) The Arts and Letters Club, founded in 1908 as a meeting place for writers, actors, musicians, and artists, began renting space in St. George's Hall in 1920 and bought the building in 1986.

A cross between these two dragon types is the watchful dragon peering out over the entrance of the first head office of Confederation Life, on Richmond Street East. Perhaps if he and his fellows had been transferred to the new headquarters in 1955, they could have protected the company from collapse nearly forty years later.

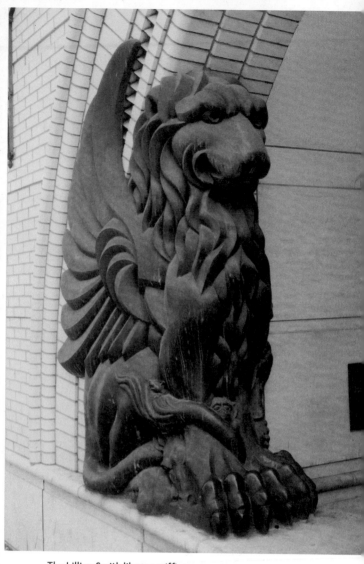

The Lillian Smith library griffins

All these other mythological things with wings have hijacked the discussion of bona fide griffins. The best-known and newest are the griffins that

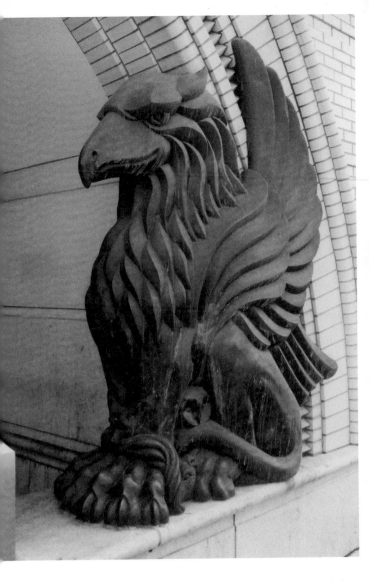

flank the entrance to the Lillian H. Smith library.
This Toronto Public Library branch, named for the
woman who pioneered library services for children
in Toronto, was opened in 1995, not far from Boys

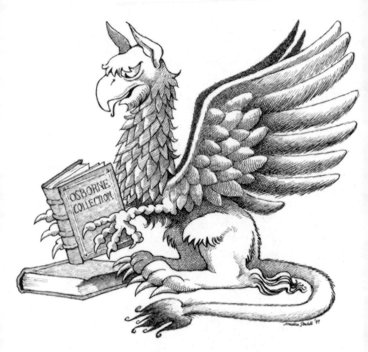

Maurice Sendak's griffin. COURTESY OSBORNE COLLECTION OF
EARLY CHILDREN'S BOOKS, TORONTO PUBLIC LIBRARY, AND THE ARTIST,
MAURICE SENDAK

and Girls House on St. George Street, which it
replaced. The library houses the Osborne Collection
of Early Children's Books and the Merril Collection
of Science Fiction, Speculation and Fantasy, as well
as a community library.

In 1969, Maurice Sendak, the children's author
and illustrator, visited the Osborne Collection in its
old home. He was reportedly so taken with the
collection that he drew a griffin for the library, which
soon became the logo of the Osborne Collection.

When twin griffins appeared on the new branch, his was assumed to be their model. But while the Sendak donation is the reason griffins are on the building at all, they were not based on it, according to architect Phillip H. Carter.

He did not want to copy it, in part because the library is more than the Osborne Collection, and in part because he did not actually like the Sendak illustration, he said in an interview. So he studied images of Etruscan and Germanic griffins, and, in collaboration with sculptor Ludzer Vandermolen, designed one from each influence.

The results were well received by architecture critics, who called the griffins "delights" (John Bentley Mays in the *Globe and Mail*) and "the greatest touches of whimsy" on a "playful toybox of a building" (Rick McGinnis in *Eye Weekly*). The library was also deemed "Toronto's most happily eccentric building" (Christopher Hume in the *Toronto Star*).

The griffins' highest praise came from Edward Kay, writing in the architectural journal *Azure*: "Large and formidable-looking, they possess the star quality that seems destined to make this place a landmark."

ANGELS

IF THIS SURVEY OF Toronto's architectural sculpture includes the varieties of wingèd beasts whose protective role necessarily entails keeping people out and away from riches inside the buildings they guard, it should give equal time to more benevolent wingèd spirits of Christianity and Judaism. Angels — apart from the avenging variety — act as personal guardians, recorders of the deeds of mankind, messengers, and symbols of victory.

Compared to the complex interrelationships of the gods and beasts of mythology, the "celestial hierarchy" of angels is fairly simple — a mere nine orders, ranging from lowly angels to the seraphim who are said to surround the throne of God. Still, the rank of angels on Toronto buildings is not always clear, and the reason for their presence is rarely apparent.

Two angels — with different robes, wings, faces, and hairstyles — greet worshippers who come to Metropolitan United Church on Queen Street East. One holds a banner that reads, "Glory to God in the highest," while his partner's says, "Worthy the lamb that was slain."

Designed by architect Henry Langley, the church had its cornerstone laid in 1870 and was dedicated in 1872. It was originally known as Metropolitan Wesleyan Methodist Church, and informally as Canada's "cathedral of Methodism." The United Church of Canada was formed in 1925 when the Methodist and Congregational and two-thirds of the Presbyterian churches in Canada joined up, and the "cathedral" became Metropolitan United Church.

Despite its striking appearance, described as High Victorian Gothic, Metropolitan United has always been known more for its sound — from its carillon and organ. In the tower is the first harmonically tuned carillon in North America, consisting of twenty-three bells and first played in 1922. (With additions in 1960 and 1971, the total has risen to fifty-four bells, the largest of which weighs 3,836 kilograms and is 183 centimetres in diameter.)

The original pipe organ was presented to the church by the daughter of Hart Massey in memory of her father. Its cost was estimated at between $50,000 and $60,000 — in 1928 dollars. So when a fire razed the church in the early morning of January 31, 1928, news coverage focused on the fate of its aural features. The carillon was spared, but the organ was lost.

(When the church was rebuilt, a new organ — the largest in Canada, built by Casavant Frères in Québec — was installed and first played in 1930. The instrument has been updated and restored over the years, but the original console remains.)

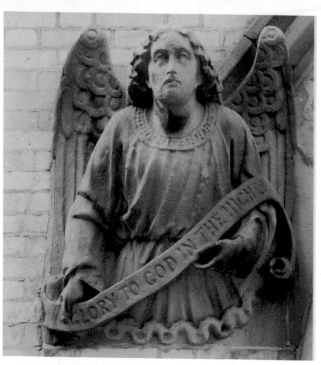

Metropolitan United Church

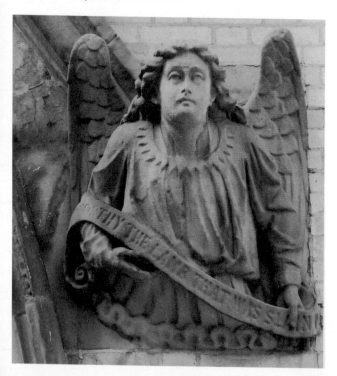

The survival of the carillon was due to the fact that, as the *Globe* headline read, the "stately tower containing carillon" remained standing. The angels are on that tower, but news coverage of the fire made no mention of whether they were on the tower at that time and what their fate was. Depending on when they were added to the tower, they can be seen as protectors during the 1928 fire — or insurance for the future.

Directly across Bond Street from the church stands St. Michael's Hospital, known as "Toronto's urban angel." Shortly after the Sisters of St. Joseph founded the hospital in 1892, they found a dirty and blackened statue of St. Michael in a pawnshop on Queen Street, for which, after considerable haggling, they paid $49. The statue stood in the Bond Street lobby until it

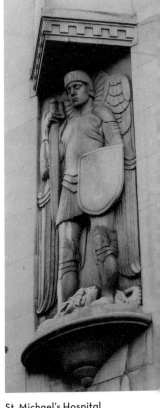

St. Michael's Hospital

was moved in 1997 to the newly built Victoria wing. At that time the name "Pietasantra" was seen carved in the back of the stone. According to the hospital's web site, the marble for the statue came from the same Italian quarry that Michelangelo used for his

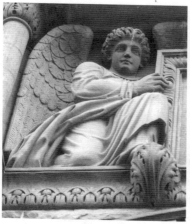
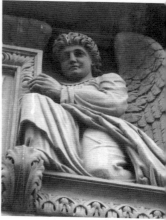

Toronto headquarters of Canadian Blood Services (formerly the Hospital for Sick Children)

famous *Pietà*. However, nothing else is known about the statue—the artist, its date of creation, or how it came to be in Canada.

But in the niche over the Bond Street entrance is another figure of St. Michael, fully outfitted with helmet, sword, and shield standing over a dragon (Satan) he has battled, as described in Chapter 12 of the Apocalypse. This sculpture, in high relief, was modelled by Frances Loring in 1936, when architect W. L. Somerville designed this addition to the hospital.

A pair of angels watches over the entrance to the building that served as the sixth home of the Hospital for Sick Children. The angels hold a plaque reading "Victoria Hospital for Sick Children," although the "Victoria" designation was never officially adopted.

Sick Kids was founded by a group of women, led by Elizabeth McMaster. The hospital first opened its doors at an Avenue Road location in 1875. The College Street building, designed by the architectural firm of Darling and Curry and built of red sandstone, opened in 1892 as the first purpose-built pediatric hospital in Canada.

By that time, the hospital had expanded and control was transferred to a Board of Trustees, the chairman of which was John Ross Robertson, publisher of the *Evening Telegram* and the hospital's major benefactor. McMaster was made "Lady Superintendent," but her tenure was short due to irreconcilable differences with Robertson.

In part, Robertson's interest in the hospital was prompted by the deaths of his daughter Goldie and her cousin Grace, both of whom died in infancy of scarlet fever in 1881.

"All stricken children became breathing reminders of Goldie and Grace," said Ron Poulton in his 1971 biography *The Paper Tyrant: John Ross Robertson of the Toronto Telegram.*

A stained-glass window, now in the current hospital building, depicting Christ holding a sick child, is a memorial to Robertson's first wife and Goldie, Poulton said. The memorial windows in the nurses' residence were dedicated for the Robertson family as well.

In extensive news coverage of the opening of the new building, the two prominent angels in high relief are briefly noted, but without explanation of their inspiration or symbolism. Robertson's own

Evening Telegram pointed to the hospital's "ornamented stone tablet with carved figures of cherubims [sic] on either side of the inscription"— but without elaboration.

Cherubim (which is already the plural form, of "cherub") make up the second-highest order of angels, described as supporting the throne of God or acting as guardian spirits. Artists transformed them into the chubby, rosy-cheeked figures we think of today. It is tempting to think that Robertson may have ordered the carvings, so that they might represent the guardian angels of Goldie and Grace, but there may be another explanation from an architect who worked on the building's transformation in the 1990s.

Sick Kids remained in the building until 1951, when it moved to its present University Avenue location. In 1991 restoration work began, and the building was adapted for the Toronto regional centre of the Canadian Red Cross Blood Transfusion Service. It is now Toronto headquarters of Canadian Blood Services, the organization that took up blood collection in Canada (except for Quebec) when the Red Cross was put out of the blood business following the HIV and hepatitis C fiascoes of the 1980s.

During the restoration work, David Driscoll of Parkin Architects Limited was taken through part of the building by former patients. They recalled that most patients in that wing did not leave alive. That suggested to Driscoll that the hospital served as the gateway to heaven for those children, and possibly the angels at the entrance were their guides.

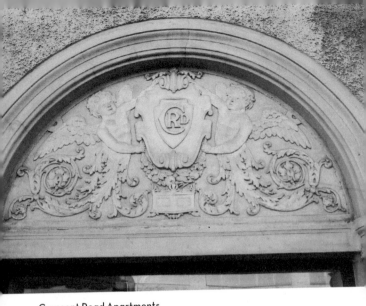

Crescent Road Apartments

Decoration on the buildings at 1046 and 1048 Yonge Street, across from the Rosedale subway station, have angelic creatures that more closely resemble the common conception of cherubs. Appearing in an arch above each large, street-level window, a pair of figures supports a shield with a large letter "c" containing the letters "RD."

The "CRD" is the clue to the building's origins as a 1926 luxury apartment building — the Crescent Road Apartments, designed by architect Charles Dolphin. According to Bob Dolphin, the architect's son, his father drew the designs himself, but he does not know what their significance is in the context of an apartment block.

Joseph Brennan, an architect who is the current owner and resident there, said the figures are not angels at all. Rather, they are "putti," which, although cherubic, are not necessarily angelic. They appear

frequently on Florentine and Tuscan coats of arms, which may have been the inspiration for an upscale apartment building, he suggested in an interview.

Another luxury apartment building also has angels. Trios of angels support the balconies of the Claridge Apartments, at the corner of Avenue Road and Clarendon Avenue, which Robert Fulford has called the "queen of apartment buildings."

It was designed in 1929 by the architectural firm of Baldwin and Greene. (Martin Baldwin was later director of the Art Gallery of Toronto, now the Art Gallery of Ontario.) It may also be better known for its lobby ceiling, painted by Group of Seven member J. E. H. MacDonald, using Spanish-American and Indian patterns and colours, and his son Thoreau MacDonald, who contributed paintings of zodiac symbols. (The doorway to the Concourse Building, another Baldwin and Greene commission, has beautiful and elaborate mosaics by both MacDonalds.)

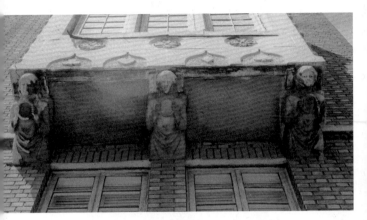

OPPOSITE AND ABOVE: Claridge Apartments

The only explanation for the angels on the Claridge is the building's Venetian Gothic style, which incorporates Moorish influences. "On the exterior the decorative detail is sometimes playful in its eclectic references to architectural history," wrote William Dendy and William Kilbourn in *Toronto Observed: Its Architecture, Patrons, and History.*

"The most fanciful are three overhanging bays on the third floor, supported on the backs of carved angels, as if above a quiet canal in Venice."

The Venetian/Moorish style appears on and in a few other notable Toronto buildings, including the former Athenaeum Building on Church Street, which is currently being adapted as part of the Jazz Condo. "Given the typical Toronto response to new ideas," said Michael McClelland of ERA Architects, "none of this aesthetic movement spirit lasted too long, the Athenaeum closed, and the style went out of fashion."

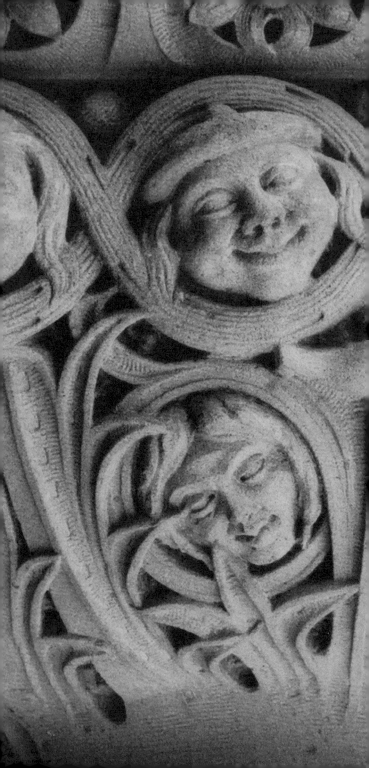

PORTRAITS
AND
CARICATURES

MANY OF THE STONE faces on Toronto buildings are portraits — or, in some cases, caricatures — of actual people. As with public sculpture, the subjects are often explorers, founders, or civic and religious leaders — heroes.

Take, for example, the Sigmund Samuel Canadiana Building, now a University of Toronto property. It was built as the provincial Archives Building in 1948, at which time Jacobine Jones was commissioned to sculpt historical figures to appear on it. The four figures chosen, who appear in high relief, are explorer Samuel de Champlain, General James Wolfe, General John Graves Simcoe, and General Isaac Brock. In addition to spending eleven months carving the figures (with the assistance of stone carvers Louis and Peter Temporale), Jones spent hours in research to ensure that the sculptures were correct in period detail and representations of the men's characters.

Champlain is depicted with a compass and the plan of the first habitation; Wolfe with a closed telescope, perhaps after surveying the Plains of

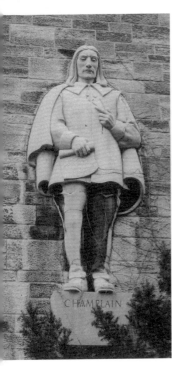

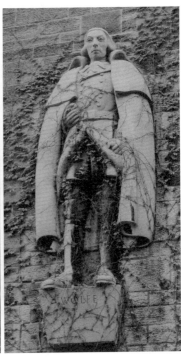

Canadiana Building. CLOCKWISE FROM UPPER LEFT: Samuel de Champlain, James Wolfe, John Graves Simcoe, Isaac Brock

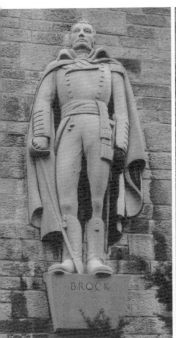

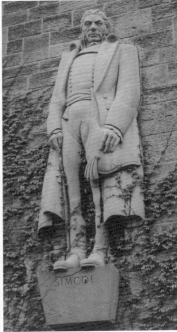

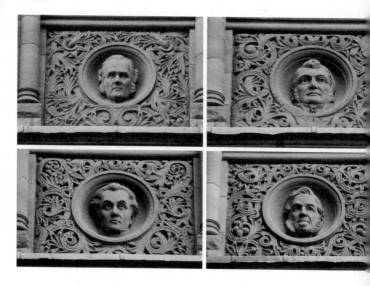

Abraham and planning the battle that would defeat Montcalm; Simcoe, the first lieutenant-governor of Upper Canada, with his walking stick and hat in hand; and Brock with his sword, as befits a hero of the War of 1812 (notwithstanding his death in the Battle of Queenston Heights).

Taken together, the progression of the nearly three-metre-tall figures follows early Canadian history, from discovery to conflict and settlement, according to Natalie Luckyj, Jones's biographer. When the scaffolding came down and the figures were revealed in 1950, *Globe and Mail* art critic Pearl McCarthy approved, saying the work would be "respected by outsiders who do not know Canadian history," adding that "it therefore adds to the story of the past a fine demonstration of Canadian culture in mid-century."

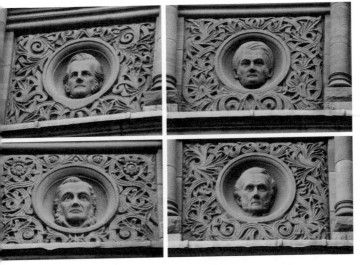

Queen's Park. TOP ROW: John Graves Simcoe; Isaac Brock; John Sandfield Macdonald; John Beverly Robinson. BOTTOM ROW: Robert Baldwin; Matthew Crooks Cameron; Timothy Blair Pardee; William Hume Blake

Of course, there are always conflicting views of art. William Dale, a curator of what was then the Art Gallery of Toronto, writing in the late 1950s, said the Canadiana Building quartet "give the impression of having been applied to the wall like animal crackers, and their colossal size plays havoc with the scale of the building."

Across the street, on the provincial legislature building at Queen's Park, two of the figures from the Canadiana Building reappear along with six others designated as heroes of Ontario history.

In addition to John Graves Simcoe and Isaac Brock, they are: John Sandfield Macdonald, the

first premier of Ontario; John Beverly Robinson, attorney general and later chief justice of Upper Canada; Robert Baldwin, a leader of the movement for responsible government; Matthew Crooks Cameron, the first leader of the Ontario Conservative party; Timothy Blair Pardee, Crown Lands commissioner and minister responsible for Ontario's first forest protection legislation in the government of Oliver Mowat, the province's third premier; and William Hume Blake, solicitor-general for Canada West and chancellor of Upper Canada in the early and mid-nineteenth century.

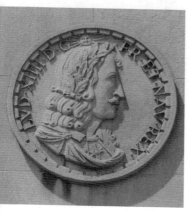

Louis XIV

They are tucked away fairly high up, under third-storey windows on the side walls of the central block. Not only are they not visible from the entrance, they have, at times, been almost completely obscured by ivy. That did not bother architectural historian Eric Arthur, who thought that finding them was half the fun. "For the lover of Ontario history, it might not be everyone's list of heroes today," he wrote in his history of the provincial parliament buildings, "but the sculpture is admirably done, and has the merit of being

obscure in its resting place and having to be discovered."

Some architects reached farther back in time for role models to appear on their buildings. Louis XIV, the seventeenth-century French "Sun King," appears with Queen Victoria on a 1929 bank building, as symbols of Canada's French and English heritage. (For a fuller discussion of these figures, see Chapter 6.)

William Thomas took his inspiration from longer ago still. On one side of the entrance to St. Michael's Cathedral, he put the carved head of Paulinus, the first bishop of York, who was respon-

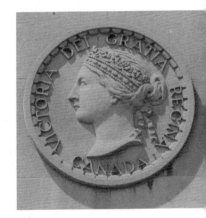

Queen Victoria

sible for converting much of northern England to Christianity. Among his converts was Edwin of Northumbria, who became the first Christian king of northern England and whose likeness appears on the other side of the cathedral's entrance.

The connection between these seventh-century saints and Toronto in the mid-1800s seems to stretch the connection between the city, formerly called York, and Mother England to extremes. But Michael Power, Toronto's first Roman Catholic Bishop, felt a special connection to Paulinus. "Perhaps Bishop

Power was hoping for similar success," suggested
Glenn McArthur and Annie Szamosi in their biog-
raphy of the architect.

Thomas memorialized Power as well by putting
a carved likeness of him on one side of the door-
way to the accompanying Bishop's Palace. But
Power did not live to see the cathedral completed.
While ministering to sick and dying immigrants

St. Michael's Cathedral. OPPOSITE: Paulinus. ABOVE: Edwin of Northumbria

who had fled Ireland's famine, he contracted typhus and died in 1847.

The figure on the opposite lintel from Power is said, by virtually all historians of Toronto architecture, including the venerable Eric Arthur, to be Thomas himself. But McArthur and Szamosi point

TOP LEFT: William Thomas?
TOP RIGHT: Bishop Michael
Power. LEFT: William Thomas,
in an undated oil painting.
CREDIT: TORONTO PUBLIC LIBRARY
(TRL) T35182

out that "no documentation or phys-
ical resemblance supports the claim."

Does it strike you as presumptuous or even
merely cheeky for Thomas to have added his own
likeness to this work? Maybe so, but such architec-
tural signatures are not unusual. If that is not
Thomas on the Bishop's Palace, he almost certainly
put his very personal stamp on two other buildings.
Thomas built Oakham House, now part of Ryerson
University, as his own residence in 1848. The door-
way, window frames, and upper corners of the
house sport twelve faces, the identities of whom are
believed to have been lost. But that is almost

ABOVE: William and Martha Thomas on Oakham House. RIGHT: William Thomas on St. Lawrence Hall

certainly Thomas himself on a first-floor window (and his wife opposite).

He also appears on the south side of St. Lawrence Hall, his masterpiece. However, the teeth were "grotesque" additions when the building was restored in the 1960s, according to John Bridges of Summit Restoration, who worked on the project.

Thomas was not the only architect to put his own face on his work. Three partners, all looking much the worse for wear, look out from the original Confederation Life Building. The elements — and thoughtless renovation — have inflicted much the same fate on them as the company suffered. One of Canada's oldest and largest companies, it collapsed

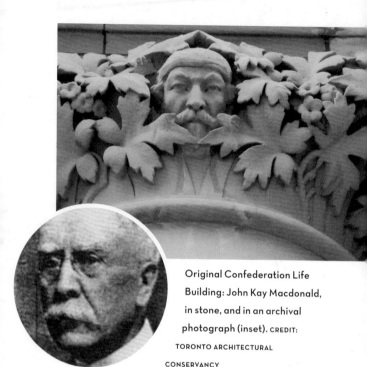

Original Confederation Life
Building: John Kay Macdonald,
in stone, and in an archival
photograph (inset). CREDIT:
TORONTO ARCHITECTURAL
CONSERVANCY

in 1994. The Romanesque building on Richmond
Street East served as its headquarters until 1955.

The firm of Knox and Elliot won a competition
for the building's design in 1890. Along with drag-
ons and foliage, Wilm Knox and John Elliot put
four sculpted heads at street level on the building's
south side. The late Edna Hudson, who produced
an entire book on this building alone, identified the
first head as that of Confederation Life founder John
Kay Macdonald. Although the company ultimately
failed, Macdonald's sculpture has survived the best,
still clearly surrounded by maple leaves and flowers.

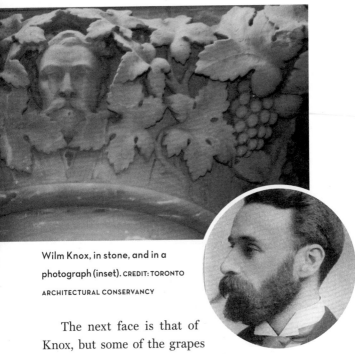

Wilm Knox, in stone, and in a photograph (inset). CREDIT: TORONTO ARCHITECTURAL CONSERVANCY

The next face is that of Knox, but some of the grapes and vine leaves that surround him have been removed through the years.

Hudson fails to name the remaining two subjects, who have sadly been cut in half. Still, comparison with pictures of other architects who worked on the building shows the next is John Siddall, and the last is Elliot — recognizable even though the elements have worn the sandstone nearly smooth.

Toronto has failed to protect some of its best buildings from demolition, especially from the 1960s onward. But the sculptures of Elliot and Siddall were probably damaged when the building was modified in the late 1800s. Pictures of the

Two sides of the mutilated archway, with the bisected faces of John Siddall (left) and John Elliot; John Siddall, in stone, and in a photograph (inset). CREDIT: TORONTO ARCHITECTURAL CONSERVANCY

building at nearly every stage of its life appear in Hudson's book, although some reproductions are quite small. Still, a careful examination of those pictures suggests that the two architects were halved when an arch they flanked was made into a secondary doorway in 1897.

One of the legendary architect self-portraits appears on Old City Hall. The building was opened as the third city hall in 1899, and, as with many government projects, was over budget. Architect Edward J. Lennox had locked horns with city coun-

John Elliot, in stone, and in a
photograph (inset). CREDIT: TORONTO
ARCHITECTURAL CONSERVANCY

cil over many construction
issues, but then he suffered
two final, apparently intolerable
indignities. The city fathers would
not let him put a plaque on the building identify-
ing him as the architect, and they stiffed him,
refusing to pay his full bill. Lennox sued, taking
the case all the way to the Supreme Court, but ulti-
mately settled for more than $100,000 less than
his invoiced amount.

The revenge he took may have been worth more
than that. "E. J. Lennox Architect AD 1899" is clev-
erly carved in stone on the upper portion of the
building. A description of the signature by the city's

Department of Property said that "the placement of the lettering and figures is concealed among the support stones, in each of the parts of the building which are set back and on all four sides. The support stones are immediately below the ledge running along these insets and this ledge is below the uppermost windows."

But that was not the only signature Lennox is believed to have left. The pillars at the main entrance of the building are capped with sculptures that are said to be caricatures of the despised city councillors. "Caricature" is putting it kindly. They look goofy, demented, grotesque, bizarre — all except for one, believed to be Lennox himself.

Every historian of Toronto architecture has either accepted that explanation or been content to perpetuate the legend. The only spoilsport was Alastair Lawrie. Now retired, he had been an editorial writer at the *Globe and Mail* who also did some bylined writing for the paper. In a 1962 story on Old City Hall, written as construction began on the then–New City Hall, Lawrie expressed his doubts: "It has long been rumored, but never verified, that the grotesque miniature faces at the entrance were caricatures of members of the city council of the day. Perhaps the best evidence for disbelieving this is that the councillors, under Mayor John Shaw…offered no objection to the decoration."

The apparent tradition of architects putting their own faces on buildings did not end at the close of the nineteenth century. Located unobtrusively, high on the western side of the provincial

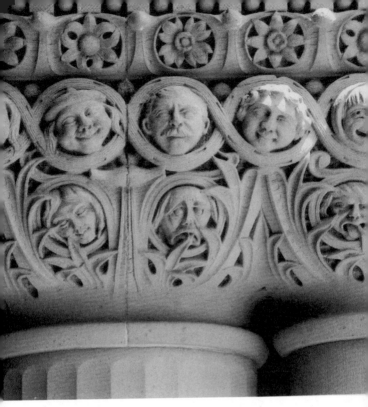

E. J. Lennox, the sane one among the caricatured city councillors on Old City Hall

parliament building, is what appears to be a life mask of—who? Although no one will go on the record, it is an open secret in heritage circles that it is architect Carlos Ventin, head of the firm that undertook restoration for the building's centennial in 1994.

Sources, who prefer not to be named, have said there had been a face in that place, but it was eroded beyond recognition. The only apparent feature was a prominent nose. At an early meeting to discuss work on the building, one architect

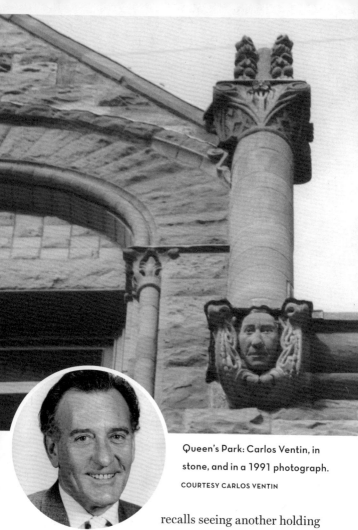

Queen's Park: Carlos Ventin, in stone, and in a 1991 photograph.
COURTESY CARLOS VENTIN

recalls seeing another holding up his pencil and closing one eye, with the open eye looking in the general direction of Carlos Ventin. He lowered his pencil to paper, began sketching, and resumed the cycle of one-eyed measuring of Ventin across the conference table and sketching the face that appears on the building today.

Queen's Park's original architect, Richard Waite, did not put a likeness of himself on the legislature — perhaps wisely. He was a controversial choice as architect, and not just because he was not Canadian. (He had been born in England, grew up in the United States, and opened an architectural office in Buffalo, New York.) Waite had been a member of the jury that judged entries to the international competition for the legislative building in 1880. None of the proposals was found acceptable, so six firms were asked to submit modified plans. Two of those were shortlisted, both from Toronto architects. Waite was appointed "expert examiner" to judge them, but he rejected those too. At that point the government, fearing that another competition would only produce further deadlock, appointed Waite himself architect.

It did not hurt that during this time, Waite "had found favour with the government both as a person and as a poker player," the late architectural historian Eric Arthur noted in his landmark book on the city's architecture, *Toronto, No Mean City*.

"The rejection of the Canadian proposals and the subsequent choice of an American to design the provincial capital building provoked a storm of protest in the legislature and in architectural circles," recounts an official history of the building. "Editorials were written decrying the choice, and the minister was under extreme pressure to explain the circumstances and justify Mr. Waite's commission."

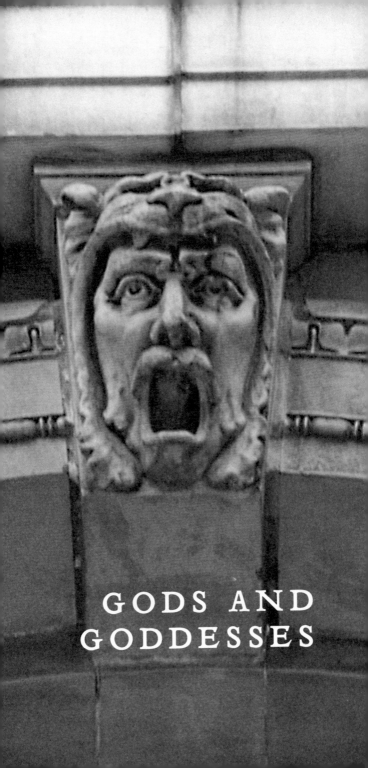

GODS AND
GODDESSES

"THE RELIGIONS OF ancient Greece and Rome are extinct. The so-called divinities of Olympus have not a single worshipper among living men. They belong now not to the department of theology, but to those of literature and taste. There they still hold their place, and will continue to hold it, for they are too closely connected with the finest productions of poetry and art, both ancient and modern, to pass into oblivion."

That is the way Thomas Bulfinch began his book *The Age of Fable, or Stories of Gods and Heroes* (only later to be called *Bulfinch's Mythology*), in which he popularized Greek myth more than 150 years ago. It also explains why the gods, goddesses, and heroes of ancient Greece and Rome have been popular subjects of architectural faces. Sometimes it is clear from their stories why particular deities appear on particular buildings, but many times the connection, unless specified by the architect, has been lost — or never existed at all.

"The details that originally had religious significance became aesthetically important," architectural

historian Sally B. Woodbridge noted in her 1991 book *Details: The Architect's Art.*

They were a kind of visual shorthand, like logos, that captured relatively complex ideas and themes in a compact way, she said. Over time, the meaning of these architectural abstractions was often forgotten, but they themselves survived because their designs, their forms, and other aspects of their appearance were pleasing. They became decoration that made up a "visual language" that architects everywhere used without any attempt to explain their meaning, Woodbridge said.

Such is the case with the appearance on Toronto buildings of various members of the Greek and Roman pantheons. One instance where the connection is clear is the Hockey Hall of Fame and its figure of Hermes (known to the Romans as Mercury), messenger of the gods. Or, the connection *becomes* clear when the history of the building is considered. It was built in 1885 as the head office of the Bank of Montreal, replacing a building that had been on the site since 1845. It remained the bank's head office until 1949, and then continued as a branch until 1982. (The Hockey Hall of Fame relocated there in 1993.)

"The manager's office [had] beautiful paneled walls and a fireplace on the south wall," Margaret McKelvey and Merilyn McKelvey said in *Toronto: Carved in Stone.* The fireplace was supported on the outside of the building by Hermes, who is also the god of commerce.

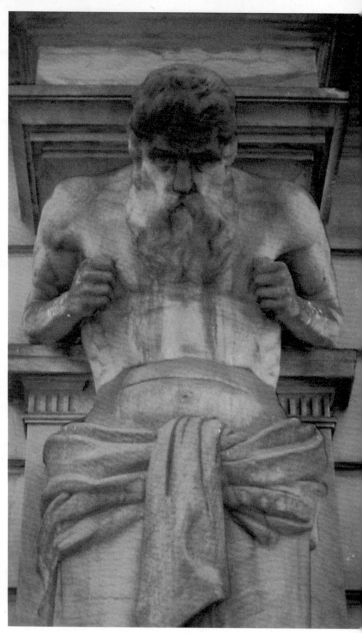

Hockey Hall of Fame: Hermes

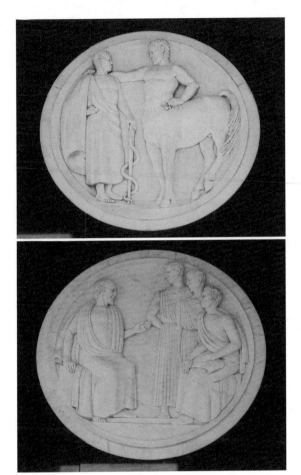

Toronto General Hospital. TOP: Asclepius and Chiron.
BOTTOM: Hippocrates and the Scribes

(Having said that, it should also be noted that at least one writer has said this figure is Atlas.)

No such background is needed to understand the medallions on the Toronto General Hospital. In the mid-1950s, Jacobine Jones was asked to sculpt two medallions, each more than 1.5 metres in diameter, out of white Carrara marble, to be

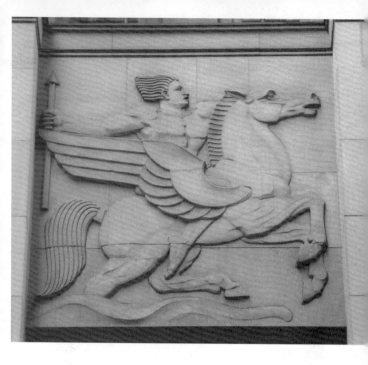

placed over the main University Avenue entrance doors to the hospital's Norman Urquhart Wing.

Although her other hospital commissions had dealt with the ages of man, here she turned to the classical roots of the medical profession. One medallion features Asclepius, the Greek god of medicine, and Chiron, the centaur who is said to have taught him the art of healing. In her notes for the Asclepius medallion, Jones also mentions his two sons and his daughters Panacea, the goddess of healing, and Hygeia, goddess of health. However, the finished product features only Asclepius and the half-man/half-horse. "I do want my centaur!" she wrote, according to Natalie Luckyj, her biographer.

Asclepius and these two daughters are invoked in the opening lines of the Hippocratic oath ("I

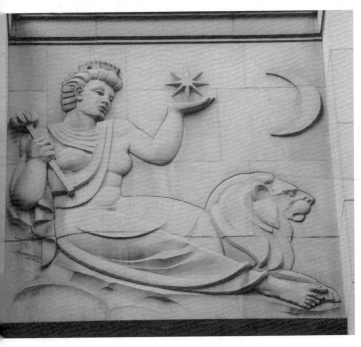

Scotiabank Plaza. OPPOSITE: Pegasus. ABOVE: Rhea

swear by Apollo the physician and Asclepius and Hygeia and Panacea and all the gods and goddesses, making them my witnesses, that I will fulfill according to my ability and judgment this oath and this covenant…"). Hippocrates, author of the oath, was not a god of myth, but a real man who lived in the fifth century B.C. He was a physician, who founded a medical school on the Greek island of Cos and is considered the father of medicine, and is represented, accompanied by scribes, in the second medallion.

Ten of the biggest names in Greek and Roman mythology appear in reliefs on the head office of the Bank of Nova Scotia: Mercury, Pegasus, Venus, Zeus, Neptune, Rhea, Prometheus, Icarus, Atlas,

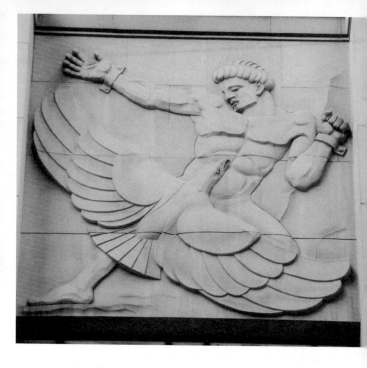

and Apollo. But it is not clear why they are there. They were not included in the building's original plans, drawn up in the early 1930s. The chosen architect, John Lyle, had a philosophical aversion to using Greco-Roman gods and goddesses and other European motifs on Canadian buildings (which will be discussed in Chapter 6). But plans for the building were shelved due to the Great Depression and the Second World War, and by the time the project was resurrected, Lyle had died.

The job was then given to architects A. S. Mathers and Eric Haldenby, who were instructed to "supervise the erection of the building in accordance with the original design." But after they brought technical aspects of the original plans up to date, they almost completely redesigned the

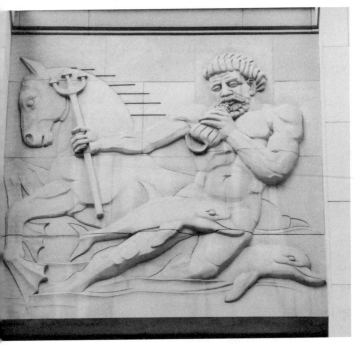

Scotiabank Plaza. OPPOSITE: Prometheus. ABOVE: Neptune

exterior. Sculptures of Greek deities were "executed in the muscular style of late-1930s heroic realism," as described by the late William Dendy and William Kilbourn in *Toronto Observed*, their survey of extant Toronto architecture in the mid-1980s.

The final examples present two puzzles. A bearded figure, emerging from the mouth of a lion, appears over the door of the Irish Embassy Pub & Grill (on Yonge Street at Wellington), and a few blocks north, over three windows on the Elgin and Winter Garden Theatres.

The first puzzle — who is the man? — is easy to solve. It is Greek strongman Hercules, who was the illegitimate son of Zeus and Alcmene. That angered Zeus' wife, Hera, as did Alcmene's attempt

to mollify her by naming the child Hercules (or Herakles in Greek, which means "glorious gift of Hera"). One of Hera's many attempts at vengeance (aimed at Hercules, by the way, and not at Alcmene) was to make him mad. In his insanity, he killed his wife and children.

Irish Embassy: Hercules and the Nemean lion

When he saw what he had done, Hercules consulted the oracle at Delphi about how to atone for his sins. The oracle instructed him to perform ten labours for Eurystheus, King of Mycenae. The first of the labours was to kill the lion that was ravaging nearby Nemea, and return with its hide.

Needless to say, Hercules successfully dispatched the Nemean lion. After throttling and skinning it, he carried the pelt back to Eurystheus on his back, using the lion's head as a helmet.

Now, for the second puzzle: what is Hercules doing on either or both of these buildings? There are no clues in the fact that the Irish Embassy building began its life as the Bank of British North America, and continued as several different finan-

cial institutions before being converted to a pub. Nor does it help that architectural writers and historians have called attention to the figures, but not explained them.

One of those writers is Hilary Russell, a former Parks Canada historian now living in Washington, D.C. Russell wrote an entire book on the theatre, in which she did not identify the faces but said they were the only theatrical touches on the building.

Elgin and Winter Garden Theatres: Hercules and the Nemean lion

"I didn't do any specific research on them," she admitted in an interview. "Perhaps by 'theatrical touches' I meant flamboyant or fantastical. I didn't realize a similar figure was being used by stodgy institutions such as banks."

Russell added, however, that many of the ornaments used by Thomas Lamb, the theatre's architect, can be found in decorating company catalogues. Which still does not explain the presence of Hercules and the Nemean lion hovering over a bank doorway . . .

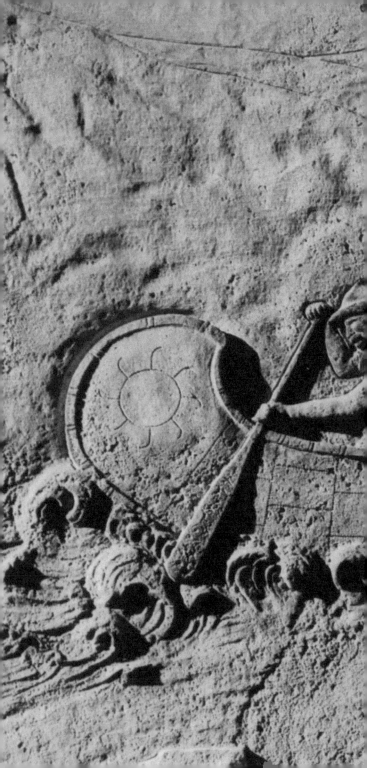

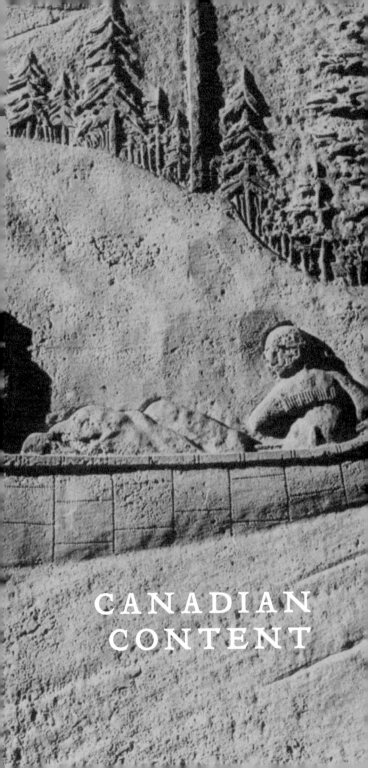

CANADIAN
CONTENT

I**T IS CLEAR HOW** and why the figures and symbols of Greco-Roman myth have persisted for millennia as architectural motifs. They met their first and only significant resistance in this country in 1931, when Irish-born, Toronto-based architect John Lyle published his manifesto calling for more Canadian content in Canadian architecture, and principally in its ornament.

"The extreme traditionalist who copies Grecian temples, Italian palaces, French chateaux or English cathedrals, is an archeologist, not an architect," Lyle wrote in an essay titled "Canadian Ornament Goes Native," which appeared in, of all places, the journal *American Architect*.

"How to strike a Canadian note in our architecture?" he asked. "It seemed to us that the field of form had been well covered in the last three thousand years, and that nothing radically new in this field was probable, but that there was a rich field of inspiration lying dormant in the fauna, flora and marine life of Canada."

Not only should any adopted figures be Canadian, "they must all pass the test of beauty," he added.

In fact, Lyle sent members of his office staff to the Royal Ontario Museum to study and make drawings of Aboriginal designs and "decorative forms," which he then included in his architectural plans.

His staff slowly grew to embrace the Canadianization of their work, Lyle reported. So it is not surprising that his clients too took a while to warm to the idea.

"In matters of taste, Lyle's patrons were essentially conservative," wrote Geoffrey Hunt, curator of a 1982 exhibition of Lyle's work. "This factor may account for the slow adoption of Canadian motifs in his bank work," Hunt added, noting that banks were the mainstay of Lyle's architectural practice.

But even a cultural institution — the Toronto Public Library — had to be persuaded. Lyle's first attempt to incorporate Canadiana in his work on a public building appeared on the 1929 Runnymede branch of the Toronto Public Library.

"Real difficulty lay in persuading the [library] board to adopt such a radical departure from the style usual in such institutions," Hunt said in his catalogue of the exhibition, *John M. Lyle: Toward a Canadian Architecture.*

The "radical" features of the building include two identical totem poles carved in stone and consisting of a raven, beaver, and bear, flanking the library's main door.

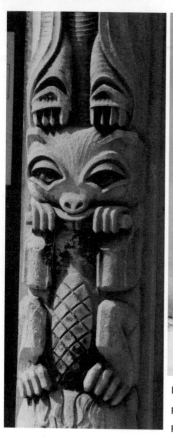

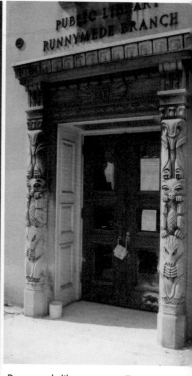

Runnymede library. ABOVE: Totem
poles in doorway. LEFT: Totem
pole detail

The "Boys and Girls" entrance on the west side
of the building "is marked by the use of an Indian
head at the keystone, and with squirrels at either
side of the frieze, suggesting a Canadian note
which at the same time would be juvenile in char-
acter," Lyle wrote of the library.

(The library has since been celebrated as an
architectural gem. For example, it was the first
building to appear in Canada Post's Canadian
architecture series of commemorative stamps
in 1989.)

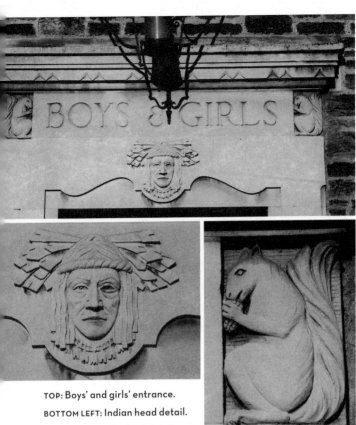

TOP: Boys' and girls' entrance.
BOTTOM LEFT: Indian head detail.
BOTTOM RIGHT: Squirrel detail

Lyle's 1930 Dominion Bank building (later a Toronto-Dominion Bank branch) at Avenue Road and Davenport Road included sculptural panels of Canadian animals and birds, many of which were incorporated in the new building that went up when the original bank was demolished in 1989.

The best surviving example of Lyle's Canadian designs may be what is now an Elephant and Castle pub, but which started life as another branch of the (Toronto) Dominion Bank, at Yonge Street and Gerrard Street West.

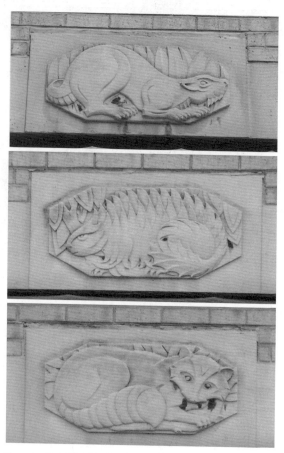

Toronto-Dominion Bank. TOP: Otter. MIDDLE: Beaver.
BOTTOM: Fox

"Ornamentation for the Runnymede library
and the Toronto Dominion Bank at Avenue Road
and Davenport were restricted in decoration to
Indian motifs and animals respectively," so this
building is "the most comprehensive Toronto

example of Lyle's Canadianization of ornamentation in architecture," said Margaret E. McKelvey and her niece Merilyn McKelvey in their 1984 book *Toronto: Carved in Stone.*

As mentioned in Chapter 4 on portraits and caricatures in stone, the Yonge Street side of the building has medallions with images of Louis XIV and Queen Victoria, representing Canada's French and English heritage.

Near the top of the Gerrard Street side are pairs of Canadian birds and vases of Canadian flowers, which the McKelveys called "accurate renderings of the riverbank gentian, the trumpet creeper and the May-apple."

But there are also two large octagonal panels with carvings representing aspects of Canadian commerce. One panel is of a steamer tied up at a wharf, while the other shows a farmer on a tractor. Until the bank closed the branch in the 1990s, the farmer was completely covered by a green TD sign.

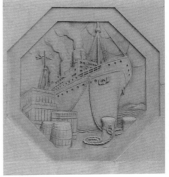

Elephant and Castle. TOP: Farmer. BOTTOM: Steamer

St. Lawrence Hall.
TOP ROW, FROM LEFT: River god of the St. Lawrence; god of Niagara; god of Lake Ontario. **BOTTOM ROW:** Music; Mirth

John Lyle may have been the most thoughtful and outspoken proponent of indigenous architecture and ornament, but he was not the first to incorporate characteristically Canadian figures in his buildings. Probably the earliest surviving building with Canadian features is William Thomas's St. Lawrence Hall, which was completed in 1851.

The *City Handbook* of 1858 noted the building's "keystones sculptured with fine colossal heads of three imaginary or symbolical river deities of St. Lawrence, Niagara and Ontario," as well as indigenous flowers and fruits.

It failed to mention, however, that higher up on the building, above the river gods, are the faces of the spirits Music and Mirth.

Another early use of Canadian content was on a Bank of Montreal building that is now home to the Hockey Hall of Fame. Completed in 1885 by the team of Frank Darling and Samuel G. Curry, the south and east façades sport sculpted shields and trophies hanging from carved masks and repre-

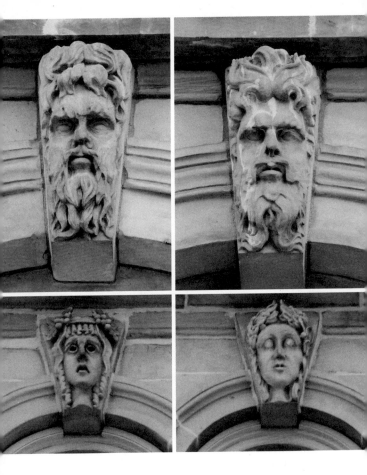

senting Canadian arts and industries, which arts journalist Katherine Ashenburg called "an almost manic sampler of classical motifs."

A few examples of the sculptures, executed by Toronto stone carvers Holbrook and Mollington, are a plow and wheat sheaves standing for agriculture, a lute and clarinet for music, a cornucopia spilling coins and ledgers for banking, and a temple with four columns for architecture. Commerce, music, architecture, and agriculture are represented on the

Front Street side, and industry, science, literature, and the arts appear on Yonge Street.

The result is "uncharacteristically ebullient for a Canadian bank, expressing the pride and economic optimism engendered by railroad," said Susan Wagg in *Money Matters: A Critical Look at Bank Architecture.*

"Until mid-century [the mid-eighteenth century], such detail was usually considered the prerogative of public architecture," added William Dendy and William Kilbourn in *Toronto Observed.* "Later it was increasingly assumed by corporate architecture as a visible sign of its importance."

The Canadianization of architectural ornament did not die with the end of the Lyle era, but it has been only occasionally pursued. But where it has been pursued, it has been done big. The largest

Hockey Hall of Fame. LEFT TO RIGHT: Commerce; Music; Architecture; Agriculture; Industry; Science; Literature; the Arts

example is the thirteen-panel history of communication designed by architect Charles Dolphin (and executed by carver Louis Temporale Sr.) in 1939–41 for the Postal Delivery Building at Bay Street and Lakeshore Boulevard. Canada Post retired the building in 1988, and it sat vacant until 1996, when it was converted into the Air Canada Centre (ACC), the home of the Toronto Raptors basketball team. At that time, Louis Temporale Jr., son of the original carver, painstakingly restored the bas-relief sculptures.

The ACC lobby includes a heritage exhibit, explaining the history of the building and providing detailed information on the sculptures. The exhibit also displays a sample panel used to test

Air Canada Centre. OPPOSITE, TOP TO BOTTOM: Speech; drumming; smoke signals; Royal Mail stagecoach.

ABOVE, TOP TO BOTTOM: Mountie escorting stagecoach; voyageurs in canoe; dog sled

various cleaning and conservation methods to restore the limestone panels that had been seriously eroded by time, nature, and salt spray from the Gardiner Expressway.

The sequence of panels begins at the northern end of the Bay Street side of the building, with human speech, drumming, 'a message in a cleft stick carried by a runner, and smoke signals. The sequence continues at the southeast corner, with depictions of nineteenth-century modes of transportation and communication: a Royal Mail stagecoach escorted by Mounties, voyageurs travelling by canoe, and Northerners by dog sled. Representing the twentieth century are a postal worker delivering mail, an amphibious aircraft, a steamship, a three-masted schooner, and a streamlined locomotive.

Crown Life. ABOVE: Deer family. OPPOSITE: Polar bear family

Dolphin, who was also an accomplished painter and illustrator, included extraordinary detail which is, despite the restoration, sometimes difficult to see unless the panels are viewed up close — which they can be, having been placed just above eye level. For example, the panicked expressions of the figures in the background of the drumming panel suggest they are

hearing news of an impending catastrophe. But it takes close inspection of the panel to discover the source of their concern — an erupting volcano.

The most recent example of overtly Canadian content appeared in 1956 on the Crown Life Insurance Building on Bloor Street East. Reliefs appear at the western and eastern ends of the building — a deer family on the former, and a polar bear family on the latter. (The date "1953" appears to the right of the bears, although the building was completed in 1956.)

According to Helen Nolan, who recently documented much of the public sculpture in downtown Toronto, sculptor Cleeve Horne wanted these animals to be integral to the building's overall design, and they were included at street level, where they can be viewed easily.

No Disneyfied characters, these. In keeping with the principles espoused by Lyle, "Horne has tried to make the animals expressive and individual — a difficult thing to do without romanticizing them," Nolan said in *Sculpture in the City*.

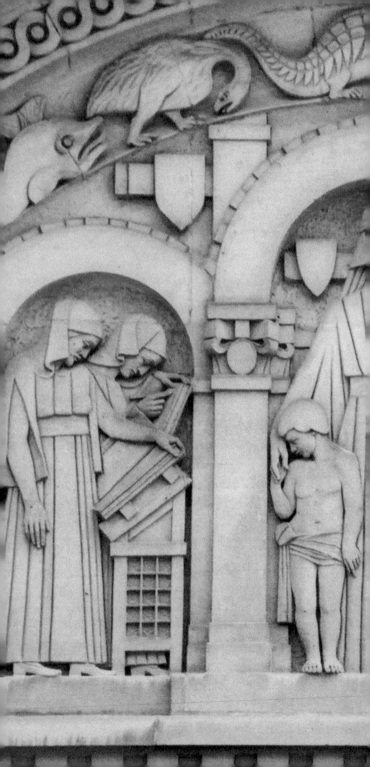

SYMBOLS
AND
ALLEGORICAL
FIGURES

NOT SURPRISINGLY, symbols make up the largest category of Toronto's faces. In most cases, the figures on the outside reflect the work being done inside, and attempt to convey greater ideals at the same time. These are often quite open to interpretation, but in several instances of series or elaborate designs, the architects had well-developed ideas about what was being represented.

A bearded man with bulging, Orphan Annie–like eyes looks out from the vermiculated rustication of the Don Jail's front doorway. ("Vermiculated rustication" is an evocative term for an equally evocative effect resulting when large blocks of masonry are carved with formations that resemble patterns left by worms.) Several writers agree that he is Father Time — not necessarily a welcoming sight, either for the prisoners who passed through the doorway or for patients who may enter when William Thomas's 1864 jail building becomes part of a new health-care complex.

"The scale is intentionally huge to dwarf the incoming prisoner or visitor," wrote William Dendy

ABOVE: Don Jail

RIGHT: Deer Park Library

and William Kilbourn in *Toronto Observed*. "Above the heavy wooden door the rusticated stones and the central keystone, with its bearded head that might personify Time, all seem on the verge of dropping down to close the door and seal it forever behind the condemned prisoner."

Current plans call for the Don Jail to be incorporated in the development of a hospital complex by Bridgepoint Healthcare, although both demolition and adaptation have come up as possible fates for the facility, which has been empty since 1978.

A warmer image appears over the doorway of the Deer Park branch of the Toronto Public Library.

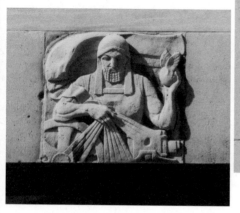

Two figures with bowed heads — one holding an open book, the other with open hands — stand on either side of a flame. The late Joan Kinsella, who prepared a history of the branch, described them as "two figures warming their hands over the lamp of learning."

A drawing of the building, designed by the Toronto firm Beck and Eadie, shows the sculpture over the door, above the third-storey window. The architects may have had the sculpture, or at least the idea for it, in hand by the time they got the commission for the Deer Park branch, which opened in 1952. That is because the sculpture appears in an early rendering — also by Beck and Eadie — for the George H. Locke Memorial branch, which was the first branch to be built during the library's post-war expansion, in 1949. Librarians at both branches and at the central library, including the library's own archivist, said they do not know why the sculpture wound up at Deer Park

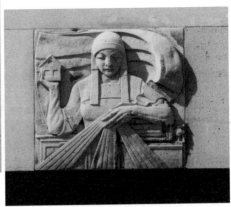

Three Toronto Hydro reliefs

instead of Locke, and library board minutes from the time do not offer clues either.

A series of intriguing panels appears above the street-level windows of the Toronto Hydro Building on Carlton Street. The original use of the 1931 building, designed by Alfred Chapman, included a ground-floor showroom, which in part dictated the kind of sculpture used just above the display windows.

Chapman himself wrote: "Commercial street architecture is so confused by the close juxtaposition of different kinds of buildings, the variation of the show windows with their awnings, the traffic and other disturbing elements, that it was felt that plain surfaces would give a relief and emphasize the essential elements of entrances and show windows. This was the reason extreme simplicity was sought, obtaining effect by proportion and a few emblematic spots of ornament so low in relief

that they would give the appearance of etching on the plain surface of the large scale masonry."

"An endeavour was made to keep the architectural detail in harmony with the equipment on display," added Howard D. Chapman in a monograph on his father's life and work, "and with the modernity associated with the electricity and for which there is no traditional suggestion."

Former York County Registry Office. ABOVE: Coat of arms. OPPOSITE: Woman atop coat of arms

Over the doorway appears the coat of arms of the old City of Toronto, featuring an Aboriginal person, Britannia, and the city motto, "Industry, Intelligence and Integrity."

The County of York coat of arms — a crest divided into four quadrants containing a deer, a tree, a wheat sheaf, and a steamship, as well as the words "Deeds Speak" — appears on a nondescript, unmarked building at the corner of Richmond Street East and Berti Street. The only sign on the building is a blue Ontario Heritage plaque marking it as being near the site of the former Canadian Institute building where Sir Sandford Fleming outlined his concept of Standard Time.

The building actually had been the York County Registry Office. Sculptures of the coat of arms (on the Berti side) and a woman standing atop the coat of arms and holding a house (on the Richmond side) are the only surviving indications of that use. The sculptures were done around 1946 by Jacobine Jones, but merited only an entry without elaboration in the biography by the late Natalie Luckyj, in an appendix listing Jones's works.

The role of the seemingly protective woman and house in that context was not explained, but she may be viewed as the patron saint of the current occupants of the building, now a men's shelter.

The Bank of Commerce — the only stone building of the current Commerce Court complex — has four guardians that watch out over the city at King and Jordan Streets. The huge, totemic heads — four on each side of the building, each more than seven metres high including more than three metres of whiskers — are

easily visible from the street, as long as the newer, taller surrounding buildings do not obscure them. The heads used to be visible up close, until the thirty-second-floor observation deck was closed.

They alternate, one grim and one grinning, around the top of the building, and represent courage, observation, foresight, and enterprise — characteristics of the institution. Or they might symbolize "the eternal vigilance of the financier looking all ways out over the country," as a *Toronto Daily Star* article of the time put it.

When the building was completed in 1931, "Sinaiticus" had some fun describing them in the journal *Construction*:

"...these colossal 'men of vision' keep unceasing vigil, north, east, south and west, over greater Toronto. The Gogs and Magogs of the city they be, and one's imagination runs riot over the happy task

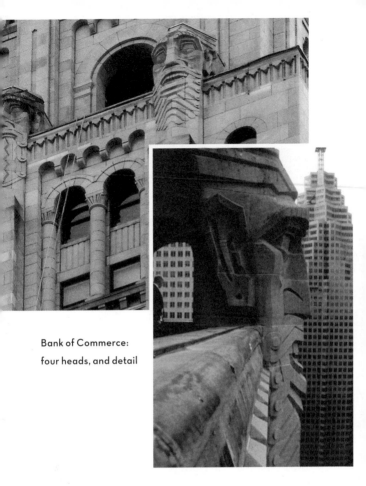

Bank of Commerce:
four heads, and detail

that Toronto's future mythologists will have, as in fanciful vein they portray the nightmare gargantuan gambols of 'the Sixteen Giants of Jordan Street.'"

The heads all have large circles cut in their earlobes — but no earrings dangling from them. It is only when older pictures are consulted that it becomes clear that the holes are left over from the days of the observation deck, when a railing ran from head to head.

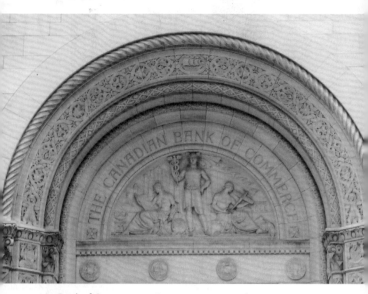

Bank of Commerce entrance

The street level of the Bank of Commerce building features a series of bas-relief plaques that "humanizes the bank's immense scale," according to arts journalist Katherine Ashenburg. The reliefs depict Canadian industries and man's need for security—including one that is a scene of the building being built, complete with those massive heads.

The "magnificent entrance [is] richly embellished with symbolic carving," added the bank's staff magazine at the time. In the arched entrance on King Street West is a semicircular sculptured panel with female figures of Industry and Commerce on either side of Mercury, god of bankers. The arch is outlined with emblems of thrift and industry, including bees and their hives.

The Royal Ontario Museum has a similarly elaborate sculptural program. The Queen's Park building was actually a 1930s addition to the original building, which became the museum's main entrance. The new building was a Chapman and Oxley commission, and Alfred Chapman left a detailed description of what he hoped to convey with the carvings.

"We do not often have a detailed account of the architect's intentions for the sculptor on a building," noted Margaret and Merilyn McKelvey in *Toronto: Carved in Stone*. "But in this case the museum's files contain a letter written by Chapman in November 1935, which outlines his ideas very precisely."

"A museum is a storehouse for articles and remains of various periods, and in designing this building we decided…to give the architectural effect and the expression of the purpose of the building," Chapman wrote.

"The central panel over the main entrance is a figure supporting the coat-of-arms of the Province on one side and the University [of Toronto] on the other. The space on the right of this figure is made up of a composition suggestive of certain elements connected with the western hemisphere, and on the left those elements suggestive of the eastern hemisphere.

"Surrounding this composition is a circular band with the signs of the zodiac carved on it. The lintel over the windows and below this composition has on it a decoration composed of a procession of gnomes suggestive of human activity.

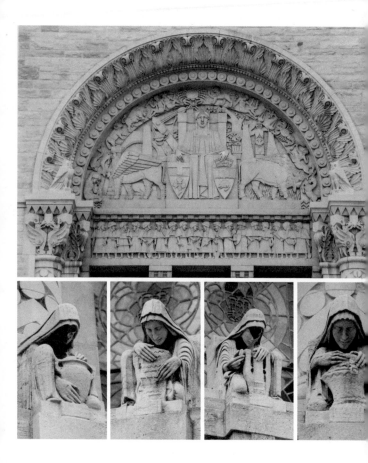

"The four hooded figures over the piers at the entrance represent four different arts: pottery, literature, music and metal work or armoury. The frieze over the doorways represents in the centre an emblem of royalty, on the right a procession of figures representing the march of humanity of the western hemisphere, on the left that of the eastern hemisphere.

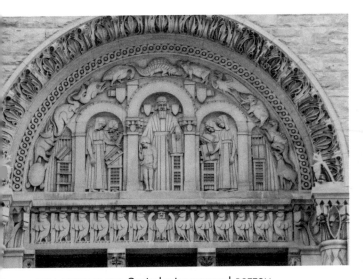

ROM. OPPOSITE, TOP: Central entrance panel. BOTTOM, LEFT TO RIGHT: Pottery; Literature; Music; Metalwork. ABOVE: Knowledge panel

"The three blocks in the centre of the tower at the top represent stone cutting of three different architectural periods."

The magnificent main entrance on Queen's Park was permanently closed in September 2005, to be replaced by a new entrance on Bloor Street West with the fall 2006 opening of the Michael Lee-Chin Crystal addition, designed by Daniel Libeskind. Until construction began for the Libeskind addition, trees obscured a striking panel on the Bloor Street side of the ROM. In Chapman's words, the scene is "suggestive of instruction with an old man in the centre representing knowledge and a child as pupil. The side figures also represent search after

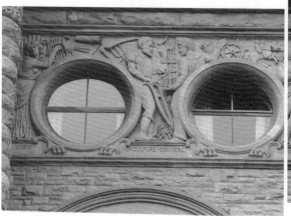
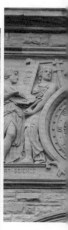

knowledge with a suggestion of a primitive printing press. These are surrounded by a band with various primitive animals used as a decorative motif suggestive of natural history."

The provincial legislature building at Queen's Park also has a highly allegorical frieze above its main entrance. More than twenty-one metres wide and nearly five metres high, the sculpture comprises figures grouped on either side of the Great Seal of Ontario. They represent music, agriculture, commerce, art, science, law, philosophy, architecture, engineering, and literature — some of the concerns of legislators inside.

By the 1920s, the provincial civil service grew too large for the main legislature building, leading to construction of the East Block of the Provincial Parliament Buildings. It is generally referred to as the Whitney Block, although it is actually five

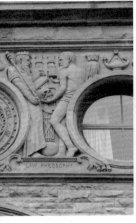
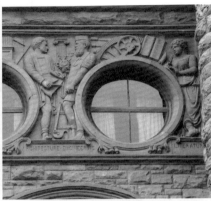

LAW PHILOSOPHY ARCHITECTURE ENGINEERING LITERATURE

ABOVE: Queen's Park
frieze. RIGHT: Whitney
Block miner and
construction worker

blocks with different
names and addresses.
It was built by F. R.
Heakes, and displays
two sets of sculptures
in high relief by
Charles Adamson.
The top-most figures
represent abstract
ideals such as truth
and justice, while
somewhat lower down
are figures standing
for "more ordinary pursuits," such as farming and
mining, the McKelveys said.

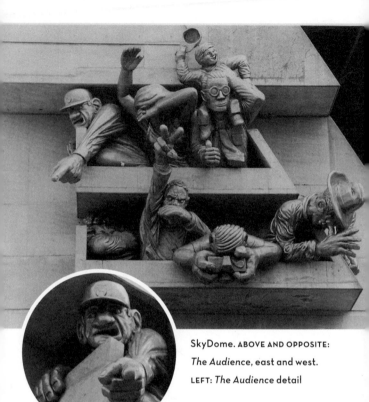

SkyDome. ABOVE AND OPPOSITE:
The Audience, east and west.
LEFT: *The Audience* detail

Figures engaged in *extra-ordinary* pursuits abound on SkyDome (now officially known as the Rogers Centre, home of the Rogers-owned Toronto Blue Jays baseball club). *The Audience* is a two-part sculpture by Michael Snow. Each section, one at the eastern end of the stadium and the other at the west, is populated by seven figures made of metallic-painted fibreglass. They are not so much representative of typical fans at a baseball game as

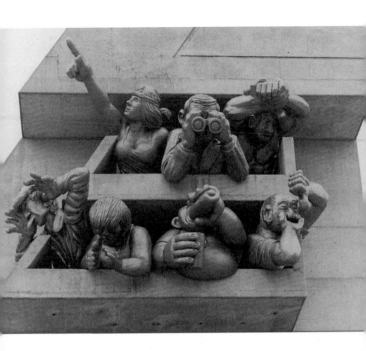

they are an audience watching and commenting on us as we arrive at the centre.

The "modern-day gargoyles," which earned Snow the 1989 Allied Arts Medal of the Royal Architectural Institute of Canada, deal with Snow's "concern with seeing and being seen," as an article in *The Canadian Architect* explained.

For those lacking imagination, who cannot guess the *Audience* members' personalities based on their facial expressions and gestures, Snow has helpfully provided a legend for each of the two groupings. The eastern audience includes the Waver, the Pointer, Camera Man, Man and Boy,

Nose Thumber, and figures he named "Oh No!" and "V is for Victory." The western assemblage is made up of Lady Pointer, Ear Wagger, Clapper, Fatso, Muscle Man, and two figures dubbed "Thumbs Down" and "Binoculars."

Several Toronto sculptures do not seem as well married to their buildings as the works already mentioned — until you know the full history of the buildings. For example, small, medieval-looking terracotta scribes and readers run along the second storey of the headquarters of City-TV, MuchMusic, and related television channels — an almost antithetical combination. But the 1913 building began life as the Wesley Building, home of the Methodist

CHUM-City. CLOCKWISE FROM LEFT: Scribe; scribe; reader; Ignorance; reader

Book and Publishing Company (later the Ryerson Press). So the two readers and two scribes become emblematic. A fifth figure, who holds neither a book nor a pen and appears to be blind, representing ignorance, stands in cautionary contrast.

Farther uptown, a kneeling naked man holds a car in one strategically positioned hand, and a wingèd tire in the other, on a building that currently houses Staples Business Depot, an office supply store. Earlier, the structure was home to CBC-TV studios. Earlier still, in 1930, it was built as a showroom for H. E. Givan and his Pierce-Arrow

car dealership. Givan's timing was not the best. The Pierce-Arrow was an expensive car, costing more than $9,000 at a time when a Model A Ford sold for about $550, and sales declined with the advent of the Great Depression. The Pierce-Arrow factory in Buffalo, New York, closed by 1938.

The details on the building were the work of Merle Foster, a well-known Toronto sculptor of the period. However, she left no publications or papers so it remains unknown why she chose the design she did, which does not resemble any logos used by Pierce-Arrow.

ABOVE: Pierce-Arrow.
OPPOSITE, TOP: Maclean-Hunter, Sending.
BOTTOM: Receiving

Back downtown, at the corner of University Avenue and Dundas, an incised naked woman floats in front of a long ribbon on one side of a building, while a naked man holding a ribbon floats on the other side. The building currently is known only by its address — 481 University Avenue — but it was until September 2005 the head office of book publisher McClelland and Stewart. In 1961, it was built for Maclean-Hunter Limited and known as the Maclean-Hunter Building, head office of *Maclean's* and *Chatelaine* magazines as well as a large stable of trade publications. Maclean-Hunter,

which had been in that location since 1911, moved to College Park in 1983, and then ceased to exist when it was bought by Rogers Communications Inc. in 1995.

When she won the commission for "exterior decorations" on the new MH building, Elizabeth Wyn Wood apparently thought the company had something more sculptural in mind.

"Symptomatic of the diminishing role and significance of sculptural decoration in modern Canadian architecture, Maclean officials agreed to only two simplified entrance panels on 'Communications,'" said Victoria Baker in her examination of Wood's life and work. "Wood interpreted this theme in the form of female and male nude figures symbolizing 'Sending' and 'Receiving,' respectively."

A tangle of faceless, ill-defined people and animals sprout from the former Bank of Canada Building at 250 University Avenue, several blocks south. Pearl McCarthy, the *Globe and Mail*'s art critic, explained that the thirty-centimetre-deep reliefs on the 1958 building represented a new approach to architectural sculpture.

"The bank saw the wisdom of eschewing any definite symbols and any definite types of Canadians," McCarthy wrote of sculptor Cleeve Horne's work. "They gave the artist a clear way to go ahead and create something which would be sculpturally gratifying to observers, and which might express the organic growth of Canada in which the Bank of Canada forms an integral element.

Bank of Canada: south and north sides

"These were praiseworthy artistic aims. Mr. Horne has compassionately suggested the human relationships of Canadians old and young, leaving the observer to form in his own mind his individual concepts of an interdependent society."

HOME ECO
FOODS
NUTRITION
DIET
CLOTHING
TEXTILES
HOME –
MANAGEMEN

196

STONES OF
CONTENTION

FOR THE MOST PART, Toronto's architectural faces are fairly inoffensive and unassuming, eliciting little public comment when they are noticed at all. However, several have engendered strong, vitriolic responses — including calls to destroy some of the sculptures.

Two muscular men holding sheaves of grain are situated above a doorway on Victoria Street — guardians of a building that has recently been the subject of some controversy. The building began its life as O'Keefe House, headquarters of E. P. Taylor's Canadian Breweries Limited (later Carling O'Keefe), which explains the symbolism of the men, as well as that of the sculpted water-bearing woman four storeys above them.

Designed and built by Toronto architects Alfred H. Chapman and J. Morrow Oxley, the building was completed in 1940. Since then, it has been the headquarters of CJRT, once Ryerson University's radio station (and now the call letters of an all-jazz radio station), and most recently it has become Heaslip House, the new home of the

university's G. Raymond Chang School of Continuing Education. But Heaslip House has only the *front* of O'Keefe House — a practice known by opponents as "façadism," the preservation of only the face of a heritage building. Proponents of the practice call it "adaptive reuse."

"You have pieces of these buildings that were designed to last hundreds of years grafted onto new buildings designed to last only a few decades. So what happens in thirty or forty years?" asked Catherine Nasmith, architect and former chair of the Toronto Preservation Board, in a *Globe and Mail* story about the building. "The thing that's really frustrating is that there are so many other places — empty spaces — to build new buildings rather than demolishing existing structures."

Heaslip House

Information from Ryerson claims the importance of the façade is that the sculptures are the work of Frances Loring.

In fact, they bear the hallmarks of Charles McKechnie, the sculptor who worked most often with Chapman and Oxley and whose best-known work is the statue of Winged Victory atop the Princes' Gates at the Canadian National Exhibition. The style of the carvings on Heaslip House is strikingly similar to that of the reliefs on the Toronto Hydro Building, discussed in Chapter 7, which were also McKechnie's work. The Heaslip sculptures' absence from a comprehensive catalogue of the sculpture of Loring and her partner Frances Wyle is added evidence against those pieces being Loring's work.

Two other architectural sculpture programs have been contentious not because of the way in which they were preserved but because of their content, in one case producing a longstanding debate, and in the other prompting calls to destruction and violence.

The debate was about one of the figures in the 22.5-metre-long frieze designed by painter Charles Comfort for the 1937 Toronto Stock Exchange Building. The new building was erected on the site when the exchange merged with the Standard Stock and Mining Exchange in the 1930s. The frieze (which serves as the groundwork for similar murals painted by Comfort on the trading floor) shows a procession of figures representing Canada's industries — labourers, white-collar workers, tycoons, and scientists among them — etched into the limestone at the second-storey level. Designed

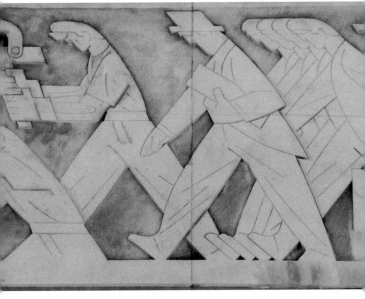

Design Exchange: Bay Street joke?

in the wake of the Great Depression, the thirty-one life-sized figures march vibrantly forward, fulfilling one of the goals of the joint exchange and its new building to restore public faith in the stock market.

The contentious part of the relief is the striding, top-hatted stockbroker whose swinging right arm is frozen over the trousers of a labourer. The press of the day apparently did not notice, but it became an inside joke in the financial community that the capitalist had his hand in the worker's pocket. A *Toronto Star* story in 1969 called the scene "a Bay Street joke preserved in granite," although Comfort denied that had been his intention.

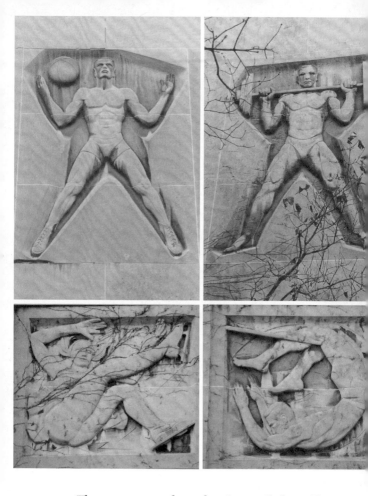

The TSE operated on the site until the mid-1980s. The building reopened as the Design Exchange, a cultural design centre, in 1994, with light standards illuminating the frieze at night — but obscuring parts of it by day.

Serious controversy erupted when four leading sculptors were asked in 1961 to adorn the new Kerr Hall at Ryerson Polytechnic Institute (now Ryerson University). Their brief, set by the architects, was

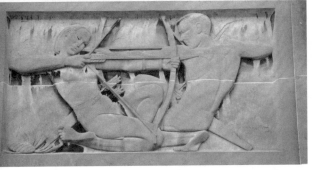

Kerr Hall. TOP, LEFT TO RIGHT: Basketball player; weight lifter; javelin thrower. BOTTOM, LEFT TO RIGHT: Skater; tumbler; archers

to create "art to represent the ideals of an institute of learning and the curriculum of Ryerson at the time." Kerr Hall is actually a quadrangle, housing a gymnasium and library as well as academic offices and classrooms, and the building thus provided eight surfaces for the sculptors to work on.

Elizabeth Wyn Wood sculpted athletes — a basketball player, weight lifter, and javelin thrower on the outside wall of West Kerr Hall, and eleven figures

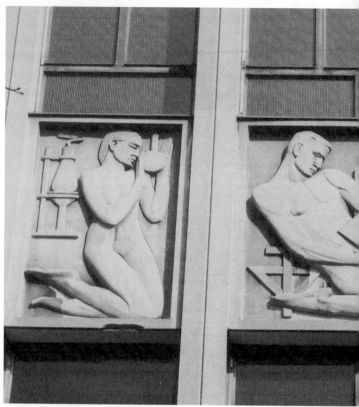

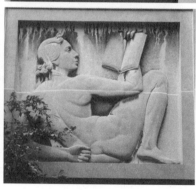

Kerr Hall. TOP, LEFT TO RIGHT: Scientist; two architects. BOTTOM: Readers

including figure skaters, tumblers, divers, and archers on the inside wall of the west building. She also designed the large sculptural mural showing various figures on the outside wall of the east hall.

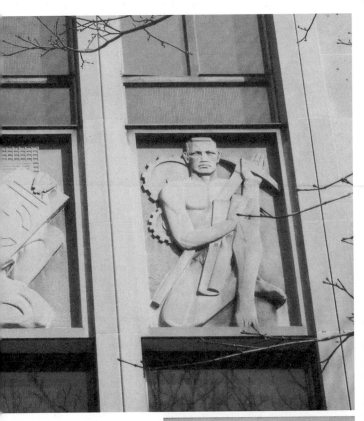

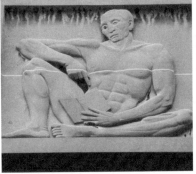

Thomas Bowie designed six reclining, reading nudes for the library on the inside west hall, and three students with flasks and microscopes, a T-square, rolled drawings, and a drawing in progress for an inside section of the east hall.

Kerr Hall. ABOVE: Outside wall with Ryerson statue.
RIGHT: Madonna and child. BELOW, LEFT TO RIGHT: Scissors;
eggbeater

Dora de Pédery-Hunt, best known for her
medal work, was asked to produce six emblems of
mother's care and housework for the inside south
wall (the Household Science Department). She
came up with scissors and thread, a garment on a

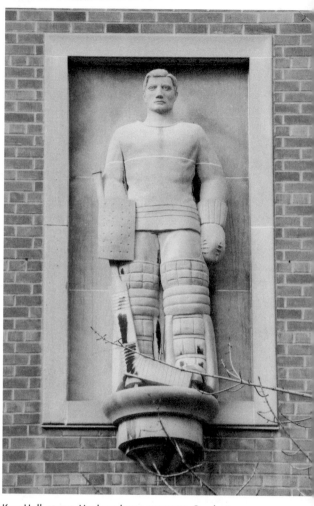

Kerr Hall. ABOVE: Hockey player. OPPOSITE: Graduate

hanger, an eggbeater, a bowl of eggs, a steam iron, and a clipboard, above which is a Madonna and child. On the outside wall, she designed emblems

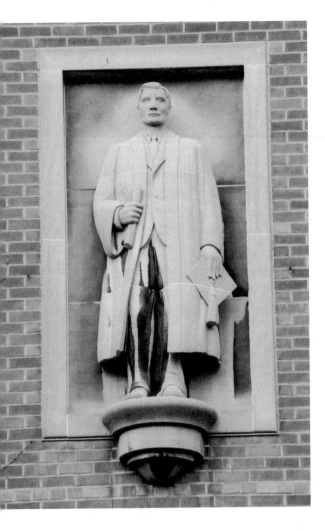

of other academic subjects — science, photography, broadcasting, and surveying.

Jacobine Jones produced a hockey goalkeeper and a graduate, in high relief, over the entrance to

the quad, on the outside wall of south hall, and based on the Ryerson motto *Mens Sana in Corpore Sano* ("A Sound Mind in a Healthy Body").

The reaction from students and faculty was fast and fierce. English instructor Lionel Willis was quoted in a campus publication as saying Bowie's treatment of human forms lacked "vigour and warmth." To which Bowie responded, "Why should there be warmth? The figures are representative of students busy at work. The figure in the top centre panel [on the library] is an instructor and the others are students directing their attention towards him."

However, the complaints focused primarily on de Pédery-Hunt's emblems and Jones's hockey player. Alberindo Sauro, the school registrar, said the sculptures would be unrecognizable thirty to forty years hence: "These silly things date the place."

Exactly, replied de Pédery-Hunt. "If they date the building it would be a very good thing — it would be an asset. I used the very latest 1962 and 1963 models in each case. In thirty or forty years it will be quite interesting to see things the way they were."

Jones also came to her defence: "Good heavens, why haven't people a sense of history? In fifty years' time we won't be using that type of eggbeater — perhaps we'll be eating pills.

"My hockey player is up to date now — right up to the minute — but who knows what they'll be wearing in future years?"

Things began to get vicious with an editorial that called the sculpture program a "monstrosity,"

adding that the Canadian art world was in need of an enema.

"There he perches, life size, in all his padded, muscular splendor," said the editorialist of the goalie, "daring opposing forwards across the street to 'dent his twines.' An almost overpowering reaction on our part is to 'dent' him and his twines with a forty-pound sledge hammer; or barring that, a thick coating of cement."

Then things turned violent. "Vandals smeared blue and red paint, and hung a life-size effigy of a pregnant woman, sporting 'red hair, a green speckled dress and a sign with $5, $10, $25 crossed out in favour of $60,000 [the cost of the project]' next to the figure," Natalie Luckyj, Jones's biographer, reported.

In the end, the effort to remove the hockey player failed, and the opponents had to take satisfaction from a gag issue of *The Ryersonian* that included the headline "Rye Murals to Come Down; Removal to Cost $100,000."

One of the contractors welcomed the controversy, suggesting it showed the sculptures were "serving their function as art. They are of little value if people don't notice them." But de Pédery-Hunt was prescient when she observed, "Architects are getting interested in putting decorations on buildings in Canada. I'm sorry there is controversy because this will discourage the use of decorations on future buildings."

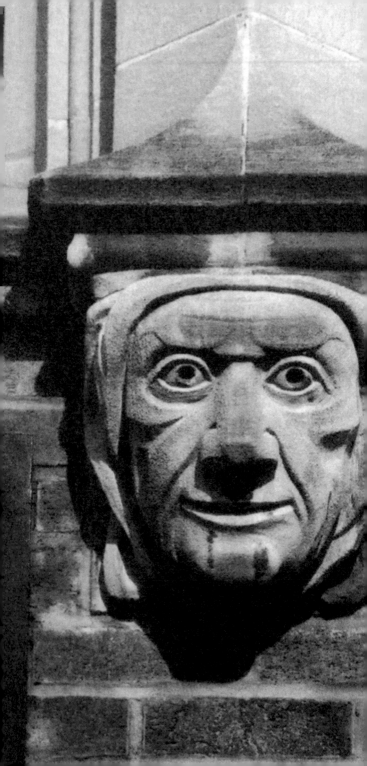

UNKNOWN
SOLDIERS

UNCLE! DESPITE READING and digging and reading more, asking, and asking again, I have found the identities of the following faces stubbornly elusive. Knowing the history of a building or the architects' or sculptors' backgrounds can be suggestive in some cases, but these are really architectural unknown soldiers. As David Driscoll of Parkin Architects Limited noted in an interview, the architects did not always say what they had in mind, and in many cases their drawings have been lost and are not in their meagre archives.

So many of these unknown faces appear to be Greco-Roman and look as though they are meant to be *somebody* — but who? A pair looks out from the main entrance of the Ontario legislature building, while a couple watch over the door of what used to be the Maclean-Hunter printing plant on Dundas Street West. These are no cartoonish caricatures. There had to have been models for this kind of detail.

The helmeted woman over the grand Roman arch that was a main entrance to the former Eaton's

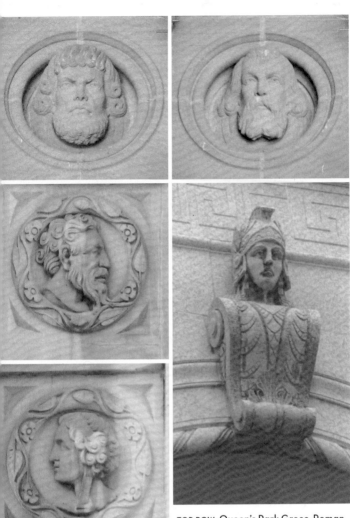

TOP ROW: Queen's Park Greco-Roman heads. LEFT: Maclean-Hunter Greco-Roman couple. ABOVE: College Park

College Street store (now College Park) may be the goddess Roma, or Britannia — but which, and why?

And who is this helmeted man watching out over the magnificent entrance to the University of

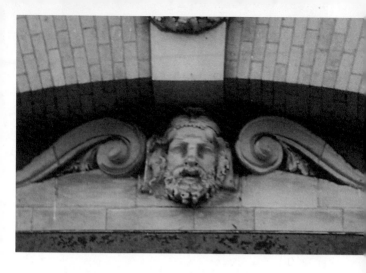

Toronto's Koffler Student Services Centre? That building was Toronto's first central library, designed by Alfred Chapman, who usually had very clear ideas about the sculpture he wanted on his buildings. (See Chapter 7 for the detailed letter he wrote outlining his intentions on the Royal Ontario Museum.)

Surely architects, especially those like Chapman, do not stick just any old generic bearded faces on their buildings. And if the figures are supposed to be members of the Greco-Roman pantheon, well, the artists might have had a little thought for those of us who cannot tell one bearded god from another, especially when all we have to go on is a face, with no identifying props such as an eagle or caduceus to help. After all, a recently published book outlining the genealogy of Greek mythology included no fewer than 3,673 named mythological figures.

Another U of T building with unexplained sculpture is the admissions office, which was originally the 1909 Dominion Meteorological Building,

OPPOSITE: Koffler Student Services. ABOVE: University of Toronto admissions: normal woman; licking reptile,

designed by Burke and Horwood. The carvings on this building do not appear to be haphazard, but what do reptiles hiding in foliage, especially the one licking a woman's hair, and the other elements over the door have to do with meteorology? What were Burke and Horwood thinking?

The Venetian Gothic–styled Claridge Apartments, with its Moorish influences, includes two isolated stones at street level that remain unexplained but are at least stylistically consistent. The stones display worn sculptures of a cello or viol player and a piper with a grinning devil looking on. Or are their musical instruments actually forerunners of those—a rebec and a shawm, both instruments which were brought back from the Arab world in about the twelfth century by the Crusaders? And the grinning demon might be *Diabolus in Musica*—the devil in music, the name given to the mysterious tritone, the musical interval of the augmented fourth or diminished fifth which spans three (whole) tones. The medieval Church rejected the dissonant-sounding tritone as being the interval of the Holy Trinity, and it became instead the interval of the Devil.

Claridge Apartments: Cellist; piper

The Canada Permanent Trust Building has thematically consistent helmeted and bearded figures at and near its

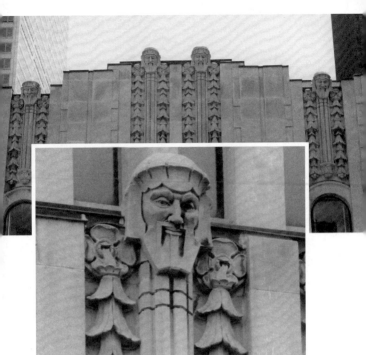

Canada Permanent Trust: Parapet, and detail

roof. In the catalogue of a 1973 exhibition on Beaux-Arts architecture in Toronto, then–U of T professor Douglas Richardson and his students drew a connection between cathedrals and temples of commerce like the Permanent. They said it was designed "with a conscious resemblance...to the tallest buildings of earlier periods, cathedral churches. Elsewhere, buildings like Canada Permanent were referred to as 'cathedrals of commerce.'

"The top of the building sports a stylized gothic parapet including turrets, gargoyles and traceried elements, all in the architect's attempt to make the building command the skyline and occupy air space in the manner of a cathedral."

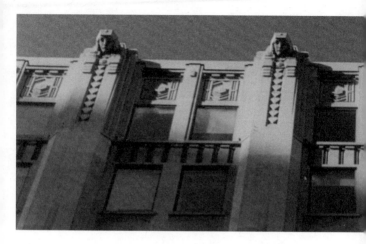

The Toronto Hydro Building on Carlton also has figures at the roofline, but architect Alfred Chapman did not appear to have ecclesiastical imitation in mind. Chapman himself noted that the "vertical motif" ends somewhat abruptly, but promised that it would be continued when the building was completed as a much higher structure (although it was never finished).

His son, architect Howard D. Chapman, suggested that the heads were echoes of the four bowed figures over the ROM's Queen's Park entrance. "The terminal motifs are…by no means as successful as their counterparts" at the ROM, he wrote in a monograph on his father's work.

St. Mary Street is a short block that seems to serve only to connect Bay Street to the Victoria University campus. The border is marked by an arched passage through Burwash Hall, built as a men's residence and refectory. In the corners of the

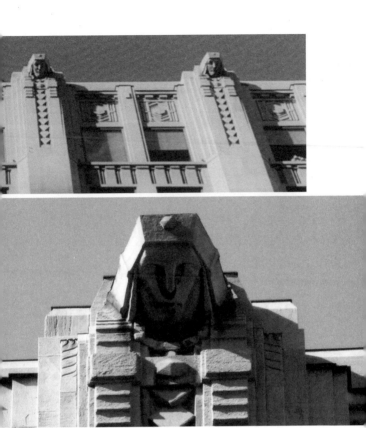

Toronto Hydro: four bowed heads, and detail

passageway, near its ceiling, are small medieval figures — glowering, wailing, or admonishing.

Even people who walk through the arch every day commented that they had never noticed these little clerics before they saw a photographer's lens trained on them, although the figures are a scant 3.5 metres up the walls. Those people are in good company. When Burwash Hall opened in 1913,

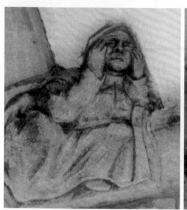

TOP AND BOTTOM: Burwash Hall clerics

W. A. Craick provided *Globe* readers with a detailed description of the short walk through the archway — but the detail stopped short of noticing the sculptures. However, Craick correctly observed that "here in Toronto there has been erected a building possessing all the architectural attractiveness and charm of an old English college." Recreating the atmosphere of Oxford was the intention of the architects, administrators, and benefactors of Vic.

Of the four ornamented secondary schools in central Toronto, only Central Technical School has

information available about its building's carved faces — despite publication of individual histories of two of the other schools, and a book devoted to art (including sculpture) in Toronto public schools. As described on Central Tech's web site, at the top of each column supporting the main entrance arch is a "gnome" — a scholar in cap and gown, busily scribbling in a book, and a journeyman with hammer and chisel, representing the two sides of the school's curriculum. (The tradesman's hammer has broken and disappeared over the years.)

Central Tech. TOP: Scholar. BOTTOM: Journeyman

Harbord Collegiate Institute and Jarvis C.I., both by school-board architect C. E. Cyril Dyson in the 1920s and 1930s, have figures so similar in style that they must have been designed by the same person. Flanking the main entrance to each building is an academic figure, and another pointing to a spherical object that may be a globe — or a ball. The latter would suggest that the figures illustrate the *mens sana in corpore sano* philosophy — healthy mind, healthy body.

The academics on the two buildings differ, however, with the Harbord character writing in a large book and the Jarvis scholar puzzling over a

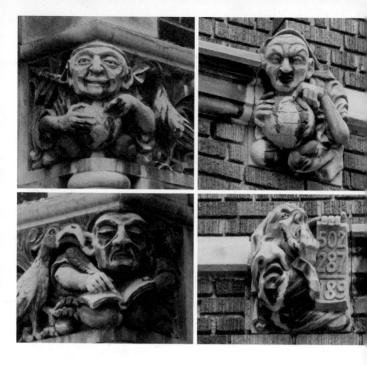

sum. And outside the third-storey art-studio window at Jarvis are more student figures, including a reader and a writer.

"You taking pictures of the funny people?" a janitor asked a photographer shooting the series of masks that appear on all four sides of Northern Secondary School, also a Dyson building.

"Funny people" they are indeed — and some are contented, goofy, frightened, frightening, or sad — but there is no information on the Oxford-like faces to be found in architectural journals, at the school itself, or in the Toronto District School Board Archives. (In fact, the archive does not even have a file on Dyson, who was the board's architect from 1921 to 1949.) An appeal for information — even pet names that students, faculty,

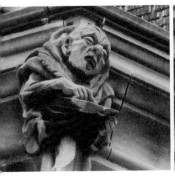
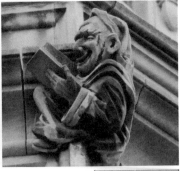

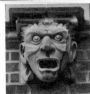
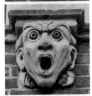

OPPOSITE, TOP ROW: Harbord ball pointer; Jarvis ball pointer. SECOND ROW: Harbord academic; Jarvis academic. ABOVE: Jarvis writer; reader. RIGHT: Northern Secondary faces

or staff may have had for their stone classmates — was posted on the web site for Northern's seventy-fifth anniversary in 2005.

"When I attended Northern between 1993 and '98, my friends and I played a lot of handball outside the south doors," Amir Fatemi, an imaginative graduate, responded. "We frequently referred to the gargoyles as the 'Handball Gods' since they could oversee everything."

Architect Dermot Sweeny applied that kind of whimsy to the sculpture near the top of the twenty-two-storey Sterling Tower. Barely visible from the ground, the figure, upon closer inspection with binoculars or from a neighbouring roof, is seen to be a wild-haired man, seemingly apoplectic, shouting into a candlestick telephone. The building was

the work of Chapman and Oxley together with engineering firm of Yolles and Rotenberg, but the surviving sons of the principals seemed not to be aware of the figure, let alone know who he is or what he represents. Sweeny, who received an award of merit from Heritage Toronto in 2002 for his preservation of the building, thinks of him as a panicked investor telling his broker to "sell!"

Sterling Tower

And what of the curious imp on the Staples Business Depot building (formerly CBC-TV studios, and originally the Pierce-Arrow showroom)? He or she — or it? — is only one element in an elaborate sculpture program on the building, much of which has been removed and lost.

The figures were modelled by Merle Foster, a popular Toronto sculptor of the 1920s through the 1950s. During the 1920s, her studio was on Walton Street, near City Hall — then a poor area of town known as "the Ward." Children flocked to her door to see the red-haired grown-up who seemed to make mud pies for a living and occasionally paid kids to pose for her. Her annual Christmas party for them attracted public and corporate donations of food and gifts from across the city, donations that continued even after she moved her studio too far away to continue the seasonal gatherings. This Pierce-Arrow

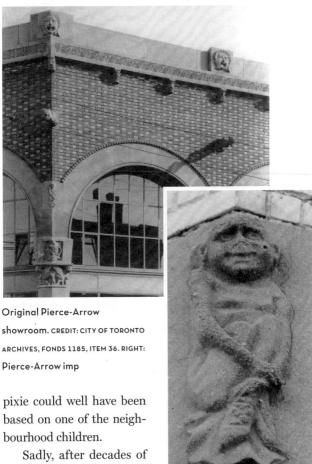

Original Pierce-Arrow showroom. CREDIT: CITY OF TORONTO ARCHIVES, FONDS 1185, ITEM 36. RIGHT: Pierce-Arrow imp

pixie could well have been based on one of the neighbourhood children.

Sadly, after decades of being the subject of stories in Toronto papers and articles in national magazines, Foster died in relative obscurity in 1986. Much of her sculpture appeared in and on buildings that have since been demolished, and organizations and companies for whom she worked have no record of her. This building is one of the few traces left of the self-described "mud-slinger" — and possibly of one of her young friends.

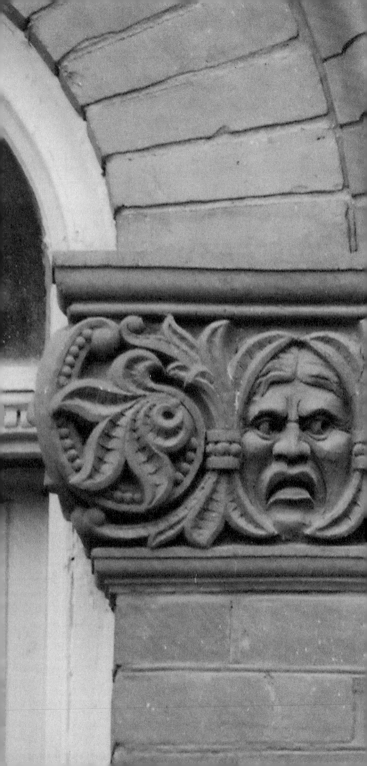

JUST
FOR
FUN.

A S WELL AS BEING symbolic, allegorical, classical, autobiographical, and memorial, Toronto's stone faces are meant to be decorative — and even fun. The late J. E. Gordon, in *Structures: Or, Why Things Don't Fall Down*, called architectural sculpture "the real heroes of Gothic cathedrals," and he provided a technical rationale for his belief that some architectural sculpture actually keeps buildings upright (as outlined in Chapter 1 on gargoyles). But in a later chapter of his book, he maintained that the true function of those figures was to "say 'boo' to the functionalists and all the dreary people who bleat too much about 'efficiency.'"

The Romanesque style, as interpreted by American architect Henry Hobson Richardson, was in vogue in Toronto for about a decade at the turn of the twentieth century. As can be seen on Old City Hall and the provincial legislature, two local examples of Richardsonian Romanesque, the style had some playful features.

Douglas Richardson, an architectural historian and former professor of fine art at the University of

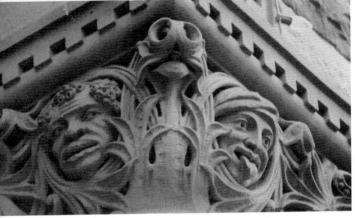

Old City Hall

Toronto, called the style "an eclectic amalgam of early medieval sources, especially twelfth-century work in southern France." In the catalogue for "Romanesque Toronto: A Photographic Exhibition of Late Nineteenth Century Architecture," a 1971 exhibition that grew out of one of his courses, Richardson said the virile style involved "massive rock-faced masonry and capacious arched entrances, the sparing use of well-placed carving,

and, above all, the subordination of the parts to the whole in a unified massing of elements."

Most of H. H. Richardson's work can be found in the Boston area (where he was based), Albany, and Pittsburgh. His style changed somewhat when it was imported to Toronto, "most noticeably by the profusion of carved ornament," Douglas Richardson wrote. That change "probably owes something to the continuing influence of John Ruskin whose theories concerning the dignity of labour and the need for the workmen to be free to express their own creative instinct had been so important earlier in the Parliament Buildings at Ottawa and in University College close at hand."

It is not clear just how free a hand the stone carvers had. James Ashby, an Ottawa conservation architect who worked with Carlos Ventin on the restoration of Queen's Park, reckoned the site architect and master mason collaborated on what faces were to be carved, leaving it to the stone carvers to follow their instruction. But he added, "When we were confronted with the challenge to replace the missing face [on the provincial legislature building, with what is widely believed to be a sculpture of Carlos Ventin himself], our choice was very much in keeping with the kind of mischievous and slightly subversive activity that has been a tradition on these historic masonry buildings."

David Driscoll, the architect with Parkin Architects who worked on the restoration of the "Victoria" Hospital for Sick Children building now occupied by Canadian Blood Services, said he

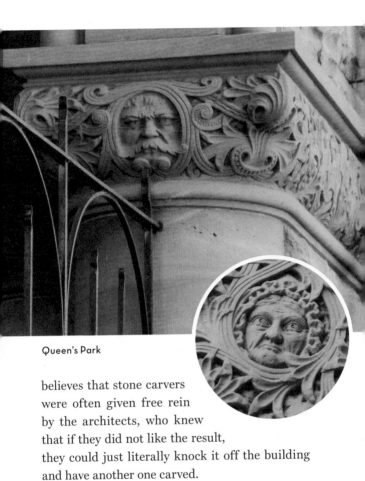

Queen's Park

believes that stone carvers
were often given free rein
by the architects, who knew
that if they did not like the result,
they could just literally knock it off the building
and have another one carved.

"Peeking out from amid the ivy, in the nooks
and crannies, on the archways, columns and balus-
trades, there are countless...carvings of famous
Canadians, gargoyles, mythical beasts, flowers, and
tangled foliage," said a provincial publication about
the legislature building at Queen's Park. "The names
of the individual carvers are unknown, but the

richness and variety of their work gives the Parliament Building a large measure of its character."

Journalist Frank Yeigh felt the same way around the time the Queen's Park building was opened. "The stone carving, taken in its entirety, is perhaps to be classed among the chief features of the building," he wrote in his 1893 book *Ontario's Parliament Buildings, or, A Century of Legislation, 1792–1892: A Historical Sketch.*

As for the foliage, Toronto's brand of Richardsonian Romanesque carving involves a lot of foliate heads: figures of stone greenery sprouting from a carved human face, or a face growing out of the leaves. They recall the "Green Man," seen from prehistoric times all over Europe and parts of Asia and believed to demonstrate the interconnectedness of man and nature.

Gooderham Building

If the faces were modelled after friends or foes of the stone carvers, that information has generally been lost. Of course, there are exceptions — but generally only in the cases of the rich and famous. In their book *East/West: A Guide to Where People Live in Downtown Toronto,* architects Nancy Byrtus, Mark Fram, and Michael McClelland cite the George Gooderham house (now the York Club) in the city's Annex neighbourhood. Holbrook and Mollington, who sculpted the house's menagerie and human faces, included one of architect Henry Sproatt, who collaborated with David Roberts on the building's design.

Another major Gooderham building in Toronto, the "Flatiron Building" (also a Roberts commission)

ABOVE AND LEFT:
Milburn Building
OPPOSITE:
Hewitt's Terrace

at Wellington and Front, has a row of faces under the eaves and a more prominent figure on one of the long sides of the building. The iconic structure is more famous for its location and shape, but the bearded man could well be George Gooderham himself.

The Annex and Rosedale neighbourhoods are particularly good hunting grounds for carved faces, but figures can also be seen on E. J. Lennox's Milburn Building on Colborne Street and on a row

of houses on Jarvis, variously known as Hewitt's Terrace and the Jarvis Historic Houses. The Jarvis houses are of particular interest for two reasons. First, built in 1889, they were restored in the 1990s by Toronto architect Steve Hilditch's company, not

so much for architectural reasons but in order to provide social housing for homeless men.

The second reason is the stone faces on the houses. It is possible to overdose on Romanesque foliate heads, which can all start to look alike, or at least like minor variations on a theme. The Jarvis faces, however, have at least two distinct styles, suggesting that they were not blindly stamped out by a single, overzealous Richardsonian.

Nevertheless, James F. O'Gorman, the Grace Slack McNeil Professor Emeritus of the History of American Art at Wellesley College and the author of a biography of Richardson, disputes whether the faces represent actual individuals. "Such faces are as common as dirt in the years around 1900," he said in an interview.

Citing faces on buildings (not all of which are Romanesque) at Harvard, Yale, and Washington University, O'Gorman added, "They are said to be

Timothy Eaton Memorial Church

portraits, but then, it is usually said that such faces are portraits. If ugly, then they are commonly said to poke fun at adversaries. On real Romanesque buildings such things are said to be a type of grotesque. Grotesques are by their nature ugly, so I'd say there was a stylistic rather than a personal reason for making these heads odd-looking."

For something completely different, return to Timothy Eaton Memorial Church (home to two of Toronto's genuine gargoyles) and look up, way up. No, not that high. Look to the band, or "string course," of the tower, which is dotted with rosettes. If you look closely, you will see that some of the them seem to have faces.

"I've seen that pretty often," said stone carver Walter Arnold. "I think it was just done for orna-mental/design reasons, to keep the place looking lively and interesting."

FACES
UNDER
PLACES

FACES IN
PLACES

THIS BOOK IS ABOUT faces *on* places. But when a building changes hands, the new owners sometimes redesign the façade, covering sculptures or moving them indoors. Needless to say, neither practice shows the carvings to their best effect or widest public.

As described in Chapter 6 on Canadian content, one of John Lyle's panels on a former Toronto-Dominion Bank building had been covered for years by a green TD sign. It was only when the bank sold the building that the relief of a farmer on his tractor was again visible. The building is now part of a chain of pub/restaurants that has dealt more sympathetically with the sculpture — the Elephant and Castle sign forms a semi-circle over the top of the octagonal panel.

The Uptown Theatre at Yonge and Bloor closed in 2003 despite attempts to save it. The building's transformation to luxury condominiums may be remembered chiefly for the structure's unplanned collapse during demolition, which killed one person in an adjacent building. Less well known is that when the modern signage, marquee, and

other coverings on the front of the theatre came down, the original 1920 Thomas Lamb façade could be seen to have two theatrical masks, which are being retained on the condo building.

Those stories had relatively happy endings for the hidden sculptures. A case of a disappearing, and then ultimately destroyed, building detail is no less egregious because it once appeared on a fairly nondescript building. A small two-storey mall near Yonge and St. Clair that seemed to be known simply as "Mall" was such a victim in 2004.

The building had been the long-term home of the Scoreboard sports bar and an independent bookstore — first Lichtman's News and Books, and more recently Book City. The mall had two wings on either side of a central door, and over the display window in each wing was a lintel showing a helmeted soldier with a griffin-like creature to his left and right.

The building was sold and demolished to make way for a fourteen-storey luxury condominium building. When the developers took over the northern storefront, they covered that window's centurion with promotional signs. When Mall was torn down, architectural scavengers — one such New York firm refers to its staff as "architecturologists" — may have claimed the panels, but few passersby had seemed aware of the lintels when the building was standing.

In 2003, a set of five limestone panels reappeared that had been on a Queen Street East building demolished in 1995. The Peoples' Optical

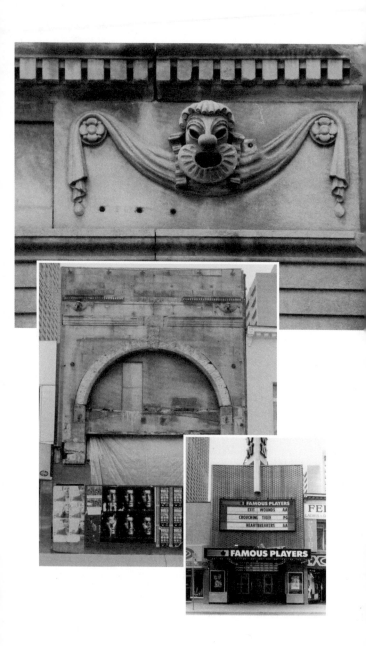

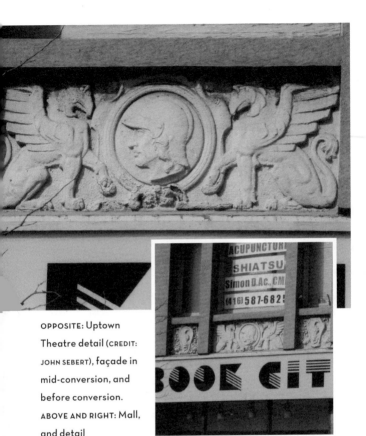

OPPOSITE: Uptown Theatre detail (CREDIT: JOHN SEBERT), façade in mid-conversion, and before conversion.
ABOVE AND RIGHT: Mall, and detail

Department was an addition that was completed after the Peoples Credit Jewellers head office was built on Yonge Street. The head office, designed by Allward and Gouinlock, had gone up on the site of the 1906 Theatorium, Toronto's first permanent movie theatre. The panels on the Queen Street building, the work of sculptor Louis Temporale Sr., were of a miner, a logger, and a steelworker as well

Peoples' Optical. OPPOSITE, CLOCKWISE FROM TOP LEFT:
Miner; steelworker; ship; fishing boat. ABOVE: Logger

as two commercial ships. The themes of modern
industry and transportation reflected the optimism
of post-war Canada.

When the building was demolished, the panels
were temporarily moved to a parking lot nearby,

Air Canada Centre

according to Kathryn Anderson of the City of Toronto's department of preservation services. They were then mounted in an entrance to the Queen Street subway station in 2003, accompanied by an explanatory plaque from the city's culture division.

One of the panels from the sequence on what used to be the Postal Delivery Building has been moved indoors, but can also be viewed free of charge. A relief carving of a postal delivery van of the 1930s (with its driver clearly visible) has been included in the heritage exhibit on the entire series in the lobby of the Air Canada Centre. (For a fuller discussion of the series, see Chapter 6, Canadian Content.)

Three lintel panels of native Canadian animals and birds on John Lyle's Dominion Bank building

at Avenue Road and Davenport remain on the renovated building, which also incorporates an office/condominium complex. However, the birds — including a pigeon and a partridge — are missing in action, and a fourth animal, a raccoon, is behind a locked (albeit clear glass) door to the vestibule of the condo building.

It is probably possible, during business hours, to enter the Rogers Communications Inc. head office on Bloor Street East to sneak a peek at the sculpture Jacobine Jones designed for the building that used to be the headquarters of Confederation Life. The artwork's relocation, though, would not have pleased Pearl McCarthy, the *Globe and Mail* art critic, who praised Confederation Life at the time for its contribution to the larger community, adding, "it is to be hoped that parents will take their children to see such [public] works."

Toronto-Dominion Bank raccoon

Rogers Communications: "Thus Is Life Liveable." CREDIT:
JACOBINE JONES FONDS, 5080.2/14/18, QUEEN'S UNIVERSITY ARCHIVES

The relief incorporates some of the ideas of
B. T. Holmes, Confederation Life's vice-president
in the mid-1950s when the company moved from its
nineteenth-century red sandstone offices on Rich-
mond. Holmes favoured an image with a traditional
view of the family, envisioning a primitive family
of five around their fire and meal, incorporating
the English translation of the corporate motto *Sic
Vita Vitalis* — Thus Is Life Liveable.

Natalie Luckyj, Jones's biographer, described the result: "Security was emphasized by the central patriarchal figure of the Father as provider, surrounded by wife (with babe) and son and daughter. The males, both semi-nude, carry bows and arrows, while the mother and daughter sport short cloaks that allow an unobscured view of their nude female bodies. A curious mix of classical resonances, naturalistic detail, and contrived poses..."

Lighting of the panel was a source of disagreement from the beginning. Holmes originally suggested that there be a red electric light in a space under the cooking pot to simulate fire—which Luckyj called "one of his more eccentric ideas."

Jones herself argued forcefully for lighting the panel from above as "the only thing that is going to bring out the modelling in the panel."

"Her chief concern," Luckyj wrote, "was the integrity of the original work." She then quoted Jones, who said, "the tremendous care and thought, plus hard labour, that goes into a work of this nature makes it heart-breaking to have the thing ruined by the wrong light."

Jones would surely be heartbroken by the Rogers treatment of the relocated sculpture, which is now lighted from below, casting the upper part of the panel, including the prominent patriarchal figure, into shadow. Suspended from the second floor, above a call centre and facing the video/wireless retail outlet, the sculpture became, according to Luckyj, "an artifact, re-contextualized and bereft of original meaning."

THE FUTURE

AFTER ABANDONING sculpture following the negative reactions to Ryerson's Kerr Hall figures, Toronto architects started to return to it with *The Audience* on the SkyDome (now the Rogers Centre) in 1989, griffins in front of the Lillian H. Smith branch of the Toronto Public Library in 1995, and the restored gargoyles on Old City Hall in 2003.

But there were no sculptural faces on any of the new buildings under construction as 2006 dawned. Six of them are cultural centres — the Royal Ontario Museum, Royal Conservatory of Music, and Gardiner Museum of Ceramic Art (all within a block of each other at Bloor and Queen's Park), the Art Gallery of Ontario, the Four Seasons Performing Arts Centre (the new home of the Canadian Opera Company and the National Ballet), and the National Ballet School of Canada. Their façades will all be smooth and unornamented glass, steel, titanium, and concrete. So the renaissance in Toronto architectural sculpture that began in the late 1980s may have had a sadly short life.

A reluctance to ornament buildings may point to deeper problems in society, or, at a minimum, a serious lack of *fun*, in the view of architect and engineer J. E. Gordon. "The truth seems to be that we are frightened to express ourselves in ornament," Gordon wrote in *Structures: Or, Why Things Don't Fall Down*. "We don't know how to handle it, and fear that we may expose the nakedness of our mean little souls. Medieval masons did not have that kind of inhibition, and they were probably psychologically healthier in consequence.

"Is it not fair to ask the technologist, not only to provide artefacts which work, but also to provide beauty, even in the common street, and, above all, to provide *fun* [Gordon's emphasis]? Otherwise technology will die of boredom.

"Let us have lots of ornament. Let there be figureheads on ships, gilded rosettes on the spandrels of bridges, crinolines on women, and, everywhere, lots and lots of flags. Since we have created a whole menagerie full of new artefacts, motor cars, refrigerators, wireless sets and the Lord knows what, let us sit down and think what fun we can have in devising new kinds of decorations for them."

San Francisco–based architectural historian Sally B. Woodbridge is an optimist who feels that because humans are ornamenting animals, we *will* continue to express ourselves — possibly in new ways. "Today, we have ceased to turn to buildings to satisfy our need for imaginative experience," she said. "The advertising industry runs the symbol mills for which graphic designers still mine the past.

Pantages Hotel and Spa. OPPOSITE: Hotel with "blind" windows. COURTESY PANTAGES HOTEL AND SPA. ABOVE: Mock-up of a sequence from *The Windows Suite*. COURTESY OF MICHAEL SNOW AND DREW GAULEY

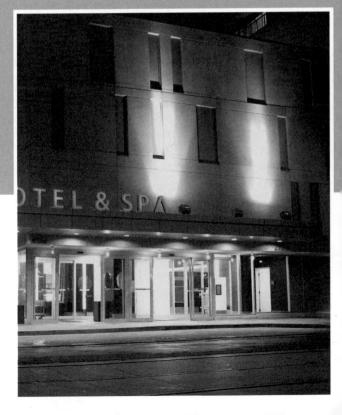

"But in our electronic age, the currents of meaning pass so quickly through images that if we want buildings to be up to the minute, we shall have to incorporate special effects into their basic palette of materials."

Although Woodbridge wrote that in 1991 (in *Details: The Architect's Art*), she seems to have anticipated a development in Toronto architecture in 2006. The Pantages Hotel and Spa on Victoria Street (which takes its name from the 1920 Pantages Theatre, now the Canon Theatre) will sport some high-tech faces scheduled to be installed in 2006. The Victoria Street façade includes several "blind" or opaque windows. Michael Snow, the artist behind *The Audience*, plans to replace the blind windows with seven plasma screens that will broadcast a complex program of people and other scenes from the windows.

In a digital video sequence that will run two hours, a person raises Venetian blinds at one window while someone else parts curtains at another in one of the thirty-two segments. The *Windows Suite* becomes almost balletic when other characters at these new "windows" move along or between storeys, such as two police officers shining a flashlight and walking past a row of screens, and a workman propping up a ladder and climbing several floors.

This is not architectural sculpture as described throughout this book, but these twenty-first-century faces on twentieth-century places may be a harbinger of the "new vocabularies of architectural detail" that Sally Woodbridge anticipated.

ACKNOWLEDGEMENTS

I HAD BEEN TAKING pictures of Toronto's architectural sculpture for years, but only with the prodding and encouragement of several people could I see that I had the makings of a book. Kathy Margittai, Joe Chiffriller, Isobel Warren, Kathy Lingo, and Roxe Murray provided the nudge and made useful suggestions for its organization and format.

Roxe, ever the project manager, also mapped out a work schedule when deadlines loomed, and read the manuscript.

Scott Beach, a true Renaissance man (right down to the chain mail), not only configured my computer system and provided technical support but also shared his photographic experience and architectural observations.

M. Ali Abdi and Adeyemi Shoga were faithful chauffeurs, scouts, and tripod-carriers.

Archivists and librarians went out of their way to make research material available to me, come hell or high water (literally): notably Marva Chung and the staff of the Periodicals and Newspapers Centre at the Toronto Reference Library, and Janice

Anderson, Visual Resources Curator at Concordia University in Montreal; as well as Kathryn Anderson of the City of Toronto Culture Division, Harold Averill of the University of Toronto Archives, Claude Doucet of the Ryerson University Archives, Sally Gibson and Glenda Williams of the City of Toronto Archives, Heather Home of the Queen's University Archives, Leslie McGrath of the Osborne Collection of Early Children's Books at the Toronto Public Library, Greg McKinnon of the Toronto District School Board Archives, Daniel Payne of the Dorothy H. Hoover Library at the Ontario College of Art and Design, Mary Rae Shantz and the staff of the Special Collections Centre at the Toronto Reference Library, and Randall Speller of the Art Gallery of Ontario Library.

The following people also gave generously of their time and knowledge: David Abernethy, Walter Arnold, James Ashby, Bruce Bell, Joseph Brennan, John Bridges, Lorne Bruce, Nancy Byrtus, Don Campbell, Angela Carr, Howard Chapman, Irma Coucill, Dora de Pédery-Hunt, Bob Dolphin, David Driscoll, Carolyn Franke, Robert Fulford, Frances Gage, John Greenhough, Ann Grotrian, Katharine Harvey, Robert Hill, Carol Hilton, Alec Keefer, Margaret Wade Labarge, Barbara Lambert, Harold Lass, Alastair Lawrie, the late Kathryn Manzer, Margaret McCaffery, Doris McCarthy, Michael McClelland, Margaret McKelvey, Peter McNally, Eleanor Milne, Tim Morawetz, Margaret Murray, Catherine Nasmith, Ed Nymark, James F. O'Gorman, Larry Wayne Richards, Ken Rotenberg, Hilary

Russell, Dermot Sweeny, Morley K. Thomas, Conan Tobias, Carlos Ventin, Leon Warmski, Bernie Weis, and Morden Yolles.

I am also grateful to the 1930s alumni of Northern Secondary School: Frances MacDonald, Donald McKerron, Dave Simms (on behalf of his aunt Elinor), Daphne Straumann, Haley Waxberg, and Sid Wilson, and especially to Amir Fatemi, a 1998 graduate.

Thanks to John Sebert for use of his photograph of the Uptown Theatre, Maurice Sendak for his griffin illustration, and Michael Snow for the mock-up of his *Windows Suite*.

A 300-mm lens doesn't always get close enough, so for access to rooftops I'm indebted to the Sergeant-at-Arms of the Legislative Assembly of Ontario, Tom Guest and Maggie Leung of Wongas Tower, Rose Mauro (formerly of Downing Street Property Management), Alka Patel and Tammy Phillips of the Fairmont Royal York Hotel, Joseph Por of the Ventin Group, and the Canadian Imperial Bank of Commerce.

Not having made the switch to digital photography yet, I relied on the expert film processing and printing skills of Nick Cassinath and the staff of Northern Artists, as well as Deborah Cox and Timmi Stein.

Friends and other family members made up an enthusiastic cheering section, including the late Jerome Murray, Judy Murray, Joan Hollobon, Kay Rex, Eve Savory, Denyse Lanouette, Paula LaRocque,

Kylie Taggart, Matt Sylvain, Teresa Tsuji, and Dan Aiken.

Finally, but by no means least, I offer heaps of gratitude to the people who actually made this a book: my agent, Robert Mackwood of Seventh Avenue Literary Agency; the designer Ingrid Paulson; and the people at House of Anansi Press, including Lynn Henry, Sarah MacLachlan, Sharon Bailey, Laura Repas, Martin Litkowski, Mitch Dermer, and Kevin Linder, a most patient editor. I am grateful for and impressed and humbled by your skills, talent, and enthusiasm for the project.

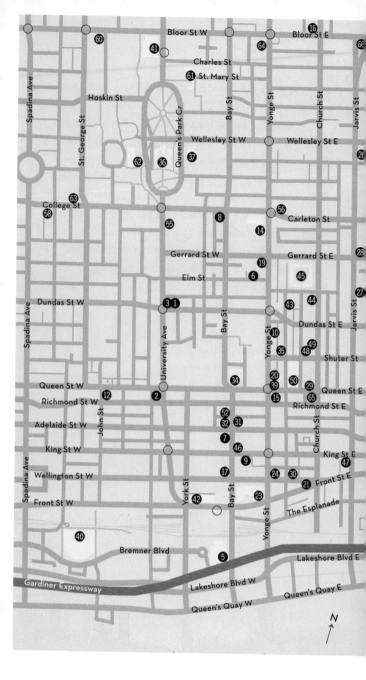

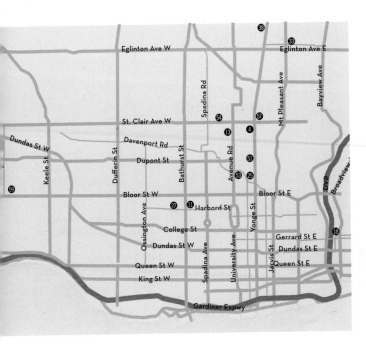

KEY

● Building location

Numbers refer to buildings listed on pages 188–194.

Building outline

----- Pathway

○ TTC subway station

PLACES WITH FACES

(A) — architect(s); (S) — sculptor; (C) — carver

① 210 Dundas Street West
Formerly Maclean-Hunter
printing plant
Murray Brown (A)
1928

② 250 University Avenue
Formerly Bank of Canada
Building
Marani and Morris (A)
Cleeve Horne (S)
1958

③ 481 University Avenue
Formerly Maclean Publishing
Company
Also known as Maclean-
Hunter Building, McClelland
and Stewart Building
Sproatt & Rolph (A)
Marani & Morris (A)
Elizabeth Wyn Wood (S)
Louis Temporale (C)
1911 (S & R)
1961 (M & M)

④ 1430 Yonge Street (demolished)
The Clairmont condominiums
(under construction)
1430 Yonge Street
Formerly Mall with Lichtman's
Also known as Book City

⑤ Air Canada Centre
40 Bay Street
Formerly Postal Delivery
Building
Charles Dolphin (A)
Louis Temporale (C)
1941

⑥ Arts and Letters Club
14 Elm Street
Formerly St. George's Hall
Edwards & Webster (A)
1891

⑦ Canada Permanent Trust
Building
320 Bay Street
F. Hilton Wilkes (A)
Mathers & Haldenby,
associates (A)
Sproatt & Rolph, consulting
architects (A)
1928–30

⑧ Canadian Blood Services
67 College Street
Formerly Victoria Hospital
for Sick Children
Also known as Canadian
Red Cross Blood Transfusion
Service
Darling & Curry (A)
1889–91

⑨ Canadian Imperial Bank
of Commerce
25 King Street West
Formerly Canadian Bank
of Commerce
Darling & Pearson (A), with
York & Sawyer (A)
1929–31

⑩ Canon Theatre
263 Yonge Street
(also 244 Victoria Street)
Formerly Pantages Theatre
Also known as Imperial
Theatre, Imperial Six Theatre
Thomas Lamb (A)
1920

⑪ Central Technical School
725 Bathurst Street
Ross & Macdonald (A)
Ross & MacFarlane (A)
1915

⑫ CHUM-City Building
299 Queen Street West
Formerly Wesley Building
(Methodist Book and
Publishing Company)
Also known as Ryerson Press
Burke Horwood & White (A)
1913

⑬ Claridge Apartments
1 Clarendon Avenue
Baldwin & Greene
(Martin Baldwin) (A)
1929

⑭ College Park
444 Yonge Street
Formerly Eaton's College
Street
Ross & Macdonald (A)
with Sproatt & Rolph (A)
1928–30

⑮ Confederation Life Building
8 Richmond Street East
Knox Elliot & Jarvis (with
John Siddall) (A)
1890–92

⑯ Crown Life Building
120 Bloor Street East
Formerly Crown Life
Insurance Co.
Marani & Morris (A)
Cleeve Horne (S)
1956

⑰ Design Exchange
234 Bay Street
Formerly Toronto Stock
Exchange
George & Moorhouse (A)
S. H. Maw, Associates (A)
Charles Comfort (S)
1937

18 Don Jail
550 Gerrard Street East
Currently being incorporated
into Bridgepoint Health
Also known as Toronto Jail
William Thomas (A)
1857–64

19 Elephant and Castle
380 Yonge Street at Gerrard
Street West
Formerly Dominion Bank
Also known as Toronto-
Dominion Bank
John Lyle (A)
1929–30

20 Elgin and Winter Garden
Theatres
189 Yonge Street
Formerly Loew's Yonge Street
Theatre and Winter Garden
Theatre
Thomas W. Lamb (A) in
association with Stanley
Makepeace (A)
1913–14

21 Gooderham Building
49 Wellington Street East
Also known as Flatiron
Building
David Roberts (A)
1891–92

22 Harbord Collegiate Institute
286 Harbord Street
Knox & Elliot (A)
C. E. C. Dyson (A) addition
1890, 1930–31

23 Hockey Hall of Fame
30 Yonge Street
Formerly Bank of Montreal
Darling & Curry (A)
Holbrook and Mollington (S)
1885–86

24 Irish Embassy
49 Yonge Street
Formerly Bank of British
North America
Also known as Canadian
Imperial Bank of Commerce
Henry Langley (A)
Burke & Horwood (A)
alteration
1873–74, 1903

25 J. R. Brennan Design Build
Inc.
1046 Yonge Street
Formerly Crescent Road
Apartments
Charles Dolphin (A)
1926

26 Jarvis Collegiate Institute
495 Jarvis Street
C. E. C. Dyson (A)
1922–24

27 Jarvis Historic Houses
285–291 Jarvis Street
Formerly Hewitt's Terrace
Knox & Elliot (A)
1889–90

28 Jarvis Street Baptist Church
130 Gerrard Street East
Langley Langley & Burke (A)
1874–75

㉙ Metropolitan United Church
56 Queen Street East
Henry Langley (A)
1870–72

㉚ Milburn Building
47–55 Colborne Street
E. J. Lennox (A)
1888–89

㉛ National Building
347 Bay Street
Chapman & Oxley (A)
1928

㉜ Northern Ontario Building
330 Bay Street
Chapman & Oxley (A)
1925

㉝ Northern Secondary School
851 Mount Pleasant Road
Formerly Northern Vocational
School
C. E. C. Dyson (A)
1930

㉞ Old City Hall
60 Queen Street West
Formerly Third City Hall
E. J. Lennox (A)
1889–99

㉟ Pantages Hotel and Spa
200 Victoria Street
Moshe Safdie & Associates (A)
Core Architects Inc. (A)
Michael Snow (artist)
2003, 2006 (art installation)

㊱ Provincial Parliament Buildings
1 Queen's Park
Also known as Queen's Park
Richard Waite (A)
E. J. Lennox (A)
1886–92, 1910

㊲ Provincial Parliament
Buildings — East Block
23 Queen's Park Circle
Consists of five blocks:
Whitney Block at 99 Wellesley
Street East;
Ferguson Block at 77 Wellesley
Street East;
Hearst and Mowat Blocks at
90 Bay Street; and
Hepburne Block at
80 Grosvenor Street
Also known as Whitney Block
F. R. Heakes (A)
Charles Adamson (S)
1925

㊳ Puma
2532 Yonge Street
Formerly Consumers Gas
Building
Also known as YWCA, Children's Book Store, Bowerings
Charles Dolphin (A)
1931

㊴ Queen Street Subway Station
(Queen and Yonge Streets)
Peoples' Optical panels
originally located on Peoples'
Optical Building, 8 Queen
Street East (demolished)
Allward & Gouinlock (A)
Louis Temporale Sr. (C)
1955
(demolished 1995)
(placed in subway 2003)

40 Rogers Centre
300 Bremner Boulevard
Formerly SkyDome
Robbie/Young + Wright (A)
Michael Snow (S)
1989

Rogers Communications
See building **66**

41 Royal Ontario Museum
100 Queen's Park
Chapman & Oxley (A)
1930–32

42 Royal York Hotel
100 Front Street West
Also known as Fairmont Royal
York Hotel
Ross & Macdonald (A) with
Sproatt & Rolph (A)
1928–29

43 Ryerson University —
Heaslip House: G. Raymond
Change School of Continuing
Education
297 Victoria Street
Formerly O'Keefe House
Also known as CJRT
Chapman & Oxley (A)
Charles McKechnie (C)
1940

44 Ryerson University —
Oakham House
322 Church Street
Formerly Oakham House
William Thomas (A)
1848

45 Ryerson University —
Kerr Hall
East Kerr Hall, 340 Church
Street/60 Gould Street;
North Kerr Hall, 31–43
Gerrard Street East;
South Kerr Hall, 40–50
Gould Street;
West Kerr Hall, 379 Victo-
ria Street
Burwell R. Coon (A) (Kerr Hall)
Lett/Smith (A) (Recreation
and Athletic Centre)
Jacobine Jones (S)
Dora de Pédery-Hunt (S)
Elizabeth Wyn Wood (S)
Thomas Bowie (S)
1954–63 (Coon)
1986–87 (L/S)

46 Scotiabank Plaza
44 King Street West
Formerly Bank of Nova Scotia
John Lyle (A)
Mathers & Haldenby (A) with
Beck and Eadie (A)
Fred Winkler (S) (C)
1949–51

47 St. Lawrence Hall
157 King Street East
William Thomas (A)
1830–51

48 St. Michael's Cathedral
57 Bond Street
William Thomas (A)
1845–48

④⑨ St. Michael's Cathedral
Rectory
200 Church Street
Formerly St. Michael's
Cathedral — Bishop's Palace
William Thomas (A)
1845–46

⑤⓪ St. Michael's Hospital
30 Bond Street
W. L. Somerville (A)
Frances Loring (S)
1936–37

⑤① Staples Business Depot
1140 Yonge Street
Formerly Pierce-Arrow
Showroom
Also known as CBC-TV studios
Sparling Martin & Forbes (A)
Merle Foster (S)
1929–30

⑤② Sterling Tower
372 Bay Street
Chapman & Oxley (A)
Yolles & Rotenberg
(Engineers)
1928

⑤③ TD Canada Trust
165 Avenue Road at Davenport
Road
Formerly Dominion Bank
Also known as Toronto-
Dominion Bank
John Lyle (A)
1930

⑤④ Timothy Eaton Memorial
Church
230 St. Clair Avenue West
Wickson & Gregg (A)
1913

⑤⑤ Toronto General Hospital —
Norman Urquhart Wing
621 University Avenue
Mathers & Haldenby (A)
Jacobine Jones (S)
1956–59

⑤⑥ Toronto Hydro Building
14 Carlton Street
Chapman & Oxley (A)
Charles McKechnie (C)
1931

⑤⑦ Toronto Public Library —
Deer Park Branch
40 St. Clair Avenue East
Beck & Eadie (A)
1952

⑤⑧ Toronto Public Library —
Lillian Smith Branch
239 College Street
Phillip Carter (A)
Ludzer Vandermolen (S)
1995

⑤⑨ Toronto Public Library —
Runnymede Branch
2178 Bloor Street West
John Lyle (A)
1929

60 University of Toronto —
Admissions Office
315 Bloor Street West
Formerly Dominion
Meteorological Building
Burke & Horwood (A)
1909

61 University of Toronto —
Burwash Hall
89 Charles Street West
Sproatt & Rolph (A)
1909–12

62 University of Toronto —
Canadiana Building
14 Queen's Park Crescent West
Formerly Royal Ontario
Museum — Canadiana
Building
Mathers & Haldenby (A)
Jacobine Jones (S)
Louis Temporale (C)
Peter Temporale (C)
1951

63 University of Toronto —
Koffler Student Services
Centre
214 College Street
Formerly Public Reference
Library
Also known as Metro Toronto
Central Library
Wickson & Gregg, A. H.
Chapman (A)
Chapman & Oxley, Wickson &
Gregg (A)
Howard Chapman & Howard
Walker (A)
1906 (W & G, C)
1928–30 (C & O, W & G)
1985 (C & W)

64 Uptown Residences (under
construction)
764 Yonge Street
Formerly Loew's Uptown
Theatre
Also known as Uptown Theatre
Thomas Lamb (A)
Mandel Sprachman (A)
1920 (Lamb)
1960s (Sprachman)

65 York County Registry Office
60 Richmond Street East
Current use is in flux
Jacobine Jones (S)
c. 1946

66 Rogers Communications
333 Bloor Street East
Marani and Morris (A)
Marani, Rounthwaite and
Dick (A) (addition)
Jacobine Jones (S)
1956, 1973

BIBLIOGRAPHY

BOOKS CITED

Arthur, Eric. *From Front Street to Queen's Park: The Story of Ontario's Parliament Buildings*. Toronto: McClelland and Stewart, 1979.

———. *Toronto, No Mean City*. Third ed. Revised by Stephen A. Otto, with new essays by Christopher Hume, Catherine Nasmith, Susan Crean, and Mark Kingwell. Toronto: University of Toronto Press, 2003.

Baker, Victoria. *Emanuel Hahn and Elizabeth Wyn Wood: Tradition and Innovation in Canadian Sculpture*. Ottawa: National Gallery of Canada, 1997.

Binder, Ingrid. *Beaux-Arts Toronto: Permanence and Change in Early Twentieth Century Architecture*. Edited and with an introduction by Douglas Richardson. Toronto, 1973. Catalogue of a photographic exhibition executed with the support of the Toronto Historical Board, and presented with the assistance of the City of Toronto Display Co-ordinating Committee, Toronto City Hall.

Boyanoski, Christine. *Loring and Wyle: Sculptors' Legacy*. Toronto: Art Gallery of Ontario, 1987. Catalogue of an exhibition held at the Art Gallery of Ontario, Toronto, July 24–October 18, 1987.

Bulfinch, Thomas. *The Age of Fable, or Stories of Gods and Heroes*. New York: Crowell, 1913.

Byrtus, Nancy, Mark Fram, and Michael McClelland, eds. *East/ West: A Guide to Where People Live in Downtown Toronto.* Toronto: Coach House Press and the Society for the Study of Architecture in Canada, 2000.

Chapman, Howard D. *Alfred Chapman: The Man and His Work.* Toronto: The Architectural Conservancy of Ontario, 1978.

Dale, Clare A. *The Palaces of Government: A History of the Legislative Buildings of the Provinces of Upper Canada, Canada and Ontario 1792-1992.* Toronto: Ontario Legislative Library, 1993.

Dendy, William, and William Kilbourn. *Toronto Observed: Its Architecture, Patrons, and History.* Toronto: Oxford University Press, 1986.

Dilse, Paul. *Toronto's Theatre Block: An Architectural History.* Toronto: Toronto Region Architectural Conservancy, 1989.

Gordon, J. E. *Structures: Or, Why Things Don't Fall Down.* Markham, Ont.: Penguin Books, 1978.

Haldane, Suzanne. *Faces on Places: About Gargoyles and Other Stone Creatures.* New York: Viking Press, 1980.

Hunchberger, Michael, Jean Irving, Carol Priamo, Wendy Pullan, and Douglas Richardson. *Romanesque Toronto: A Photographic Exhibition of Late Nineteenth Century Architecture.* Toronto: University of Toronto Department of Fine Art, 1971. Published in conjunction with the exhibition at Hart House Art Gallery, University of Toronto, May 17–June 27, 1971.

Hunt, Geoffrey. *John M. Lyle: Toward a Canadian Architecture.* Kingston, Ont.: Agnes Etherington Art Centre, Queen's University, 1982. Catalogue of an exhibition held at the Agnes Etherington Art Centre, London Regional Art Gallery, Art Gallery of Ontario, New Brunswick Museum, and Nova Scotia Museum, December 6, 1981–March 27, 1983.

Luckyj, Natalie. *Put on Her Mettle: The Life and Art of Jacobine Jones.* Manotick, Ont.: Penumbra Press, 1999.

McArthur, Glenn, and Annie Szamosi. *William Thomas, Architect, 1799–1860*. Ottawa: Archives of Canadian Art, 1996.

McHugh Patricia. *Toronto Architecture: A City Guide*. Second ed. Toronto: McClelland and Stewart, 1989.

McKelvey, Margaret E., and Merilyn McKelvey. *Toronto: Carved in Stone*. Markham, Ont.: Fitzhenry and Whiteside, 1984.

Museum of Fine Arts (Houston) and Parnassus Foundation. *Money Matters: A Critical Look at Bank Architecture*. Toronto: McGraw-Hill, 1990. Catalogue of an exhibition at the Museum of Fine Arts.

Nolan, Helen. *Sculpture in the City: Twelve Walks in Downtown Toronto*. Toronto: Artworks Press, 2003.

Poulton, Ron. *The Paper Tyrant: John Ross Robertson of the Toronto Telegram*. Toronto: Clarke, Irwin, 1971.

Sebert, John. *The Nabes: Toronto's Wonderful Neighbourhood Movie Houses*. Oakville, Ont.: Mosaic Press, 2001.

Woodbridge, Sally B. *Details: The Architect's Art*. With photographs by Roz Joseph. San Francisco: Chronicle Books, 1991.

Yeigh, Frank. *Ontario's Parliament Buildings, or, A Century of Legislation, 1792–1892: A Historical Sketch*. Toronto: The Williamson Book Company, 1893.

ADDITIONAL READING

Benton, Janetta Rebold. *Holy Terrors: Gargoyles on Medieval Buildings*. New York: Abbeville Press, 1997.

Burden, Ernest. *Building Façades: Faces, Figures, and Ornamental Detail*. New York: McGraw-Hill, 1996.

Crist, Darlene Trew. *American Gargoyles: Spirits in Stone*. With photographs by Robert Llewellyn. New York: Clarkson Potter, 2001.

Harding, Mike. *A Little Book of Gargoyles.* London: Aurum Press, 1998.

———. *A Little Book of the Green Man.* London: Aurum Press, 1998.

Hunt, Marjorie. *The Stone Carvers: Master Craftsmen of Washington National Cathedral.* Washington, D.C.: Smithsonian Institution Press, 1999.

King, Stephen. *Nightmares in the Sky: Gargoyles and Grotesques.* Photographs by f-stop Fitzgerald. Markham, Ont.: Penguin Books Canada, 1988.

Litvak, Marilyn M. *Edward James Lennox: "Builder of Toronto."* Toronto: Dundurn Press, 1995.

Sewell, John. *Doors Open Toronto: Illuminating the City's Great Spaces.* Toronto: Alfred A. Knopf Canada, 2002.

INDEX

Permission is gratefully acknowledged to reprint excerpts from the following:

Alfred Chapman: The Man and His Work by Howard D. Chapman (The Architectural Conservancy of Ontario, Toronto, 1978). Reproduced by permission of Howard D. Chapman.

Put on Her Mettle: The Life and Art of Jacobine Jones by Natalie Luckyj (Penumbra Press, Manotick, Ont., 1999). Excerpts reproduced by permission of the publisher, Penumbra Press, www. penumbrapress.ca.

Romanesque Toronto: A Photographic Exhibition of Late Nineteenth Century Architecture by Michael Hunchberger, Jean Irving, Carol Priamo, Wendy Pullan, and Douglas Richardson (University of Toronto Department of Fine Art, Toronto, 1971). Reproduced by permission of Douglas Richardson.

Structures: Or, Why Things Don't Fall Down by J. E. Gordon (Penguin Books, Markham, Ont., 1978). Copyright © 1978 J. E. Gordon. Reproduced by permission of Penguin Books Ltd.

Toronto: Carved in Stone by Margaret E. McKelvey and Merilyn McKelvey (Fitzhenry and Whiteside, Markham, Ont., 1984). Reproduced by permission of Fitzhenry and Whiteside.

Toronto Observed: Its Architecture, Patrons, and History by William Dendy and William Kilbourn (Oxford University Press, Toronto, 1986). Reproduced courtesy of Oxford University Press.

Image of the Griffin drawing reproduced courtesy of the Osborne Collection of Early Children's Books, Toronto Public Library, and the artist, Maurice Sendak.

Every reasonable effort has been made to contact the holders of copyright for materials quoted in this work. The publishers will gladly receive information that will enable them to rectify any inadvertent errors or omissions in subsequent editions.

TERRY MURRAY is an award-winning journalist and photographer specializing in medicine. For more than twenty years she has been on the staff of *The Medical Post*, a weekly newspaper for Canadian doctors. Her articles and photographs have also appeared in numerous general-interest publications in Canada, the United States, Europe, Australia, and New Zealand. She has also contributed gargoyle photographs and articles to the New York Carver web site (www.newyorkcarver.com). Since taking up gargoyle-hunting ten years ago, she has developed a permanent crick in her neck from looking up.